GREAT PAINTINGS
FROM THE
JOHN AND MABLE RINGLING
MUSEUM OF ART

Library of Congress Catalog Card No. 85-81062
ISBN No. 0-916785-21-4

Cover: Simon Vouet
 French, 1590-1649
 Mars and Venus, c. 1640
 oil on canvas, SN 360

GREAT PAINTINGS FROM THE JOHN AND MABLE RINGLING MUSEUM OF ART

Anthony F. Janson

THE JOHN AND MABLE RINGLING MUSEUM OF ART

CONTENTS

FOREWORD

In 1986 the John and Mable Ringling Museum of Art proudly celebrates 40 years of state ownership. Ten years after Ringling's death in 1936 the museum became the property of Florida and opened to the public three years later. Ringling's express intention from the beginning was that it become the state art museum of Florida, which it has been officially designated since 1980. His remains a feat without parallel in this country. None of the other great American collectors of Ringling's era shared this altruistic motive. Moreover, he formed his collection on the colossal scale that marked his circus showmanship.

His activity began several years after he met the Munich art dealer Julius Böhler through Arthur Keller, the owner of the Ritz Hotel. In 1925 Böhler and Ringling traveled to Italy in search of decorative columns, urns and sculpture for a hotel Ringling planned to build in Sarasota; these now adorn the museum. While there, Ringling acquired Veronese's *Flight into Egypt* and Luini's *Madonna and Child with Saints Sebastian and Roche*, no doubt at Böhler's suggestion. Three years later the museum was built and the collection installed in 1929. Within the period of only six years he bought some 625 paintings. In addition to Böhler, Ringling was advised by London dealers such as Duveen and Agnew, as well as scholars and curators. At the same time, he sometimes acquired large collections, including much of the remaining Emile Gavet collection from Mrs. O.H.P. Belmont and a third of the Cesnola collection of Cypriot art when it was deaccessioned by the Metropolitan Museum of Art in 1928.

The onset of the Great Depression in 1929 prevented Ringling from realizing his desire to refine his holdings. The death that same year of Mable, who had shared his love of art, was a further blow from which he never recovered. If the painting collection is therefore uneven, it remains remarkable for its quality and depth. While he bought masterpieces by the important artists of other major schools, Ringling assembled one of the great repositories of baroque painting, which for him meant art between about 1550 and 1775. The reasons for this concentration are not hard to find. In the 1920s and early 1930s, baroque painting was out of favor, so that a new collector could carve out a niche for himself in this area at relatively reasonable cost, although it should be added that Ringling paid what were fabulous prices at the time for the key works which still form

the cornerstones of the collection. More to the point was the personality of the man himself. There can be little question that he had an innate sympathy for an era whose character was much like his own. The baroque was marked by epic theatricality and illusionism; they formed a splendid, if artificial, facade that reflected the rich complexity of the era while masking its inner contradictions. The largest part of Ringling's holdings is in Italian art. Nevertheless, if any single acquisition can be said to epitomize his taste, it is the Rubens tapestry cartoons, which brilliantly embody these very qualities.

It was inconceivable, of course, that the Ringling Museum of Art could continue collecting at anything like the same pace. The resources of the estate hardly permitted it after being settled among the heirs. The Museum has by no means stood still, however. Indeed, many of the works featured in this catalogue were acquired over the past forty years. Their diversity reflects the different perspectives of the four previous directors — Everett Austin, Kenneth Donahue, Curtis Coley and Richard Carroll — each of whom made important additions to the collections, as did a succession of distinguished curators. This standard of excellence has been consistently maintained through recent purchases of major paintings by Jacob Jordaens and Mattia Preti.

The emphasis of this catalogue is rightly on the baroque paintings that form the core of the collections. Since 1972, however, the Ringling Museum has been acquiring and exhibiting contemporary painting and sculpture. Surely the art of the present is no less significant than that of the past, which it illuminates. How, indeed, can we fully appreciate the Old Masters if we do not understand the achievements of our own time? Lately the Museum has become active in the decorative arts as well. It is through such new directions that the Ringling Museum of Art continues to fulfill its vital role as the leading cultural institution of the state of Florida.

Dr. Laurence J. Ruggiero
Director

PREFACE

This book makes no claim to doing justice to the extraordinary paintings collection at the Ringling Museum. Nothing short of a comprehensive catalogue can do that. Rather, this survey has a more modest task: to provide a readable body of interpretive material for our many visitors. Though a certain familiarity with art is assumed, it was not written with the art historian in mind. On the other hand, I have not hesitated to address scholarly issues that are central to understanding several particularly thorny works; I can only hope that the reader will bear with me. In this task I have relied heavily on the catalogues already published by William E. Suida, Peter A. Tomory, William H. Wilson, and Denys Sutton, as well as more recent material.* The responsibility for the text, and therefore any deficiencies, rests with me, however.

I have kept the number of entries to a manageable number for the sake of the reader and out of practical necessity. The number 40 was conveniently provided by the anniversary celebration. Because it is intended as a useful guide to the key works in the museum, I have arranged them in approximately the order that they can be seen in the galleries, rather than observing a textbook chronology. Other important works, grouped by nationality and sometimes bearing new attributions, are illustrated at the back of the volume. They provide a clearer idea of the strengths of the collection, notably in Italian art.

I should like to take this opportunity to thank the people who have been so helpful to me. Librarian Lynell Morr managed to obtain numerous books and interlibrary loans, and tracked down a variety of factual problems. Our registrars Pamela Palmer and Wendy McFarland were of great assistance in wending my way through the historical files. Julie Caton helped to update the provenance, bibliography and exhibition history of each painting. Howard Agriesti cheerfully took new photographs of many of the works illustrated in this volume. Curatorial secretary Elaine Chamberlain

attended to a myriad of chores, particularly correspondence with other scholars. Prof. Brian D'Argaville provided especially helpful suggestions about the Preti, as did Prof. R.A. d'Hulst about the Jordaens; Dr. Beverly Brown kindly read the two most problematic entries. I am grateful to Nancy van Itallie for her sympathetic editing of the text and to Elizabeth Telford, Head of Implementation, for proofreading the final galleys. I owe a special word of thanks to Jim Waters, who designed this handsome volume and oversaw its production. Above all I wish to express my gratitude to my long-suffering wife, Helen, who once again agreed to be the guinea pig for my writing and helped to prevent it from becoming total gibberish.

Finally, I should like to dedicate this book to the staff of the Ringling Museum. There is not a finer group of people anywhere.

Dr. Anthony F. Janson
Chief Curator

*I have abbreviated them throughout the text as follows:

Suida: W. E. Suida, *A Catalogue of Paintings in the John and Mable Ringling Museum of Art*, Sarasota, 1949.
Tomory: P. A. Tomory, *Catalogue of the Italian Paintings before 1800*, The John and Mable Ringling Museum of Art, Sarasota, 1976.
Wilson: W. H. Wilson, F. Robinson, and L. Silver, *Catalogue of the Flemish and Dutch Paintings 1400-1900*, The John and Mable Ringling Museum of Art, Sarasota, 1980.
Wildenstein: D. Sutton, *Masterworks from the John and Mable Ringling Museum of Art*, Wildenstein Galleries, New York, 1981.

GREAT PAINTINGS
FROM THE
JOHN AND MABLE RINGLING
MUSEUM OF ART

The Master of 1518 (Jan van Dornicke)
Flemish, active c. 1505-c. 1530
THE ADORATION OF THE MAGI, late 1520s
oil on panel, 48 x 32. Bequest of Karl Bickel. SN 927

As early as 1505, after a decade of fruitlessly reviving early Netherlandish styles, the painters known today as the Antwerp mannerists began to infuse their art with a heightened expressiveness by reverting to gothic elements. Like the Italian mannerists, they reacted against normative ideals that had reached a level of perfection precluding further development, and emphasized a subjective vision of religious experience. Early Antwerp mannerism is characterized by contorted poses, irrational space, and elaborate decoration. Soon, however, it was influenced decisively by the Romanists Jan Gossaert and Bernard van Orley, who returned from the Holy City with the high renaissance classicism that tempers this *Adoration of the Magi*.

The subject was a favorite of the Antwerp mannerists, because it afforded a full range of exotic types in the three kings and a rich display of decoration in their precious offerings. Although it is typical of other representations by the school, this beautifully rendered and preserved panel bears the distinctive trademark of The Master of 1518: as here, the faces in his paintings often have expressions of tender concern. The dignified magi, robust Christ Child, and idealized Virgin indicate that this is a late work done toward the end of the 1520s. The Master of 1518 has been identified with Jan van Dornicke. One of the leading painters of his time in Antwerp, Dornicke was the teacher and father-in-law of Pieter Coecke van Aelst, and through him, an important bridge to the next generation of artists.

Provenance: George Arnold H. . .; Duke of Northland; American Art Association, New York, May, 1932; Karl Bickel, Sarasota.

Bibliography: Wilson, no. 2

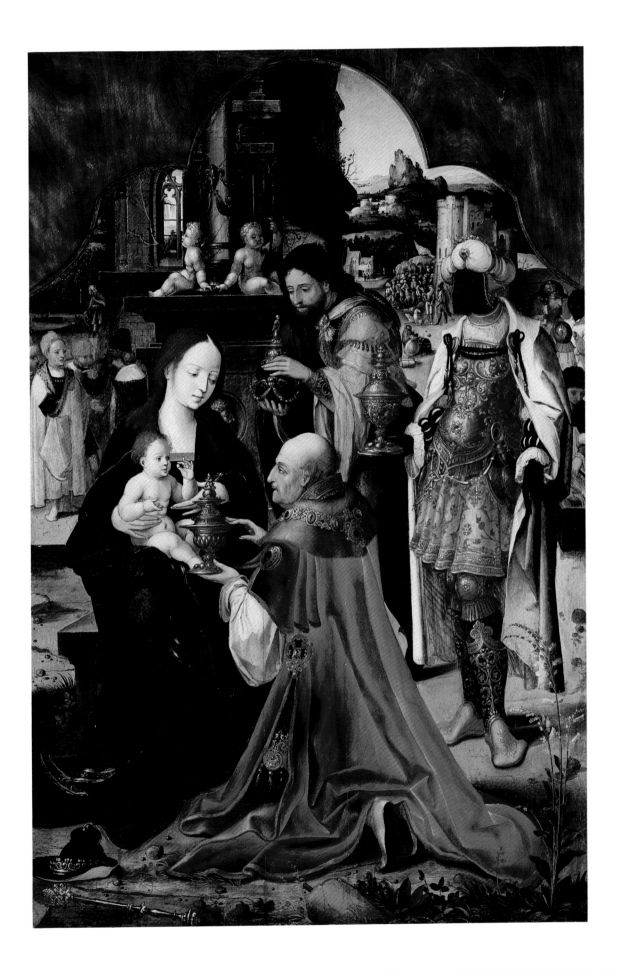

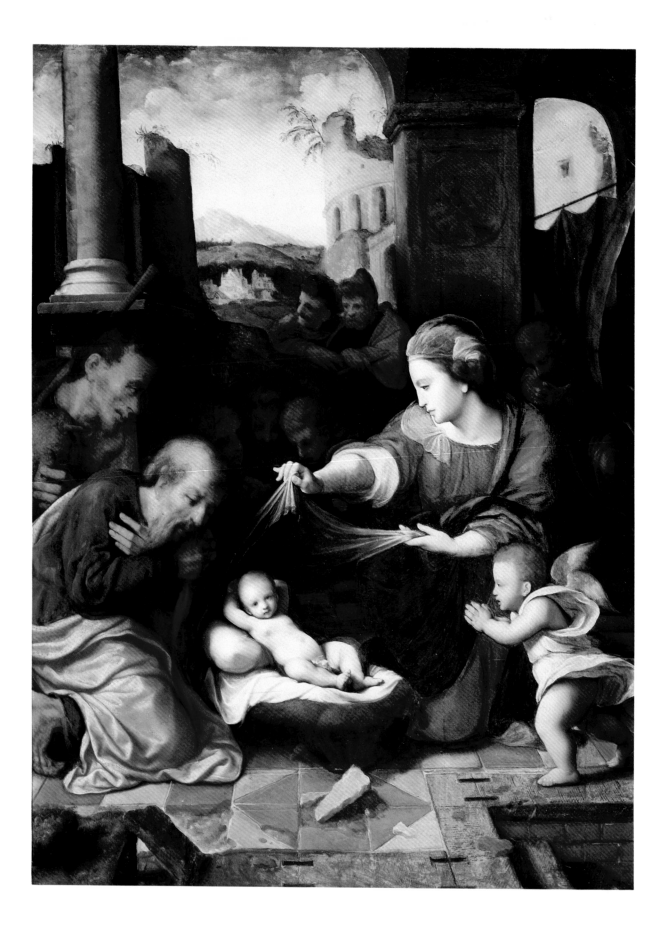

Cornelis van Cleve
Flemish, 1520-c. 1554
NATIVITY, 1540s
oil on panel, 42 7/8 x 32 5/8. SN 201

Cornelis was the son of the illustrious Antwerp artist Joos van Cleve and probably became a master in the guild a year after his father's death in 1540. He is said to have gone insane during a visit to England in 1554 and presumably died shortly thereafter. Not surprisingly, his youthful works (such as two Adorations of the Magi in the Detroit Institute of Arts and the Nelson-Atkins Gallery, Kansas City) adhere closely to those of Joos and partake of the same northern renaissance and mannerist tendencies. In addition, Italian influences recur throughout Cornelis's work, from an early Bellinian *Allegory* to a late *Leda* (present collections unknown). Although it is tempting to hypothesize a trip to Italy at the start of his career, the increasing reliance on Italian art is representative of Flemish painting by 1540 when Antwerp mannerism, its force spent, was subsumed by Romanism and ceased to have an independent existence.

The Ringling *Nativity* was first attributed to Cornelis by Max Friedländer, who defined his artistic personality. The subject exists in two versions from the artist's early years. A panel in the Dresden Gemäldegalerie is close in style to *The Adoration of the Magi* (Koninglijk Museum voor Schone Kunst, Antwerp), which remains the cornerstone of his oeuvre; another one in the Turin Pinacoteca, though different in style, is evidently by the same hand. The Ringling painting is a fully mature work. It accords with an *Adoration of the Shepherds* (Hampton Court) and a *Virgin and Child* (Alte Pinakothek, Munich) that belong to Cornelis's late activity.

The composition is a brilliant paraphrase of the *Madonna of the Diadem* (Louvre, Paris), executed around 1510 in Raphael's studio from his design by Lucca Penni. Cornelis can have known it, however, only through the intermediary of a tapestry cartoon by Tommaso Vincidor (Louvre, Paris), which was brought to Brussels to be woven for Pope Leo X in 1521. He introduced shepherds from the cartoon but translated them into characteristically rough-hewn Flemish types. It is nevertheless apparent from the noble profile of Mary that he fully comprehended the disciplined rhythms of Raphael. To these he has added Leonardo's palette of rich browns and blues, as well as a *sfumato,* or haze, which softens the contours. (Compare *The Madonna of the Rocks,* Louvre, Paris.) Despite the diversity of these sources, the Ringling *Nativity* achieves a striking originality through the pearlescent flesh tones, which set the Virgin and languorous Christ Child off from their surroundings.

Provenance: John Webb Gallery, London; Christie, London, December 14, 1928, no. 133; W. Sabin Gallery, London.

Bibliography: Suida, no. 201; M. Friedländer, *Early Netherlandish Painting,* rev. ed., New York, IXa, 1972, p. 74, pl. 134 c. 24; Wilson, no. 10.

Lucas Cranach the Elder
German, 1472-1553
Hans Cranach?
German, 1503?-1537
CARDINAL ALBRECHT OF BRANDENBURG AS ST. JEROME, 1526
oil on panel, 49 x 35 1/4. SN 308

The fascination with antiquity and its art, so natural to Italy, was alien to the north, where the renaissance properly speaking did not take place. There was nevertheless a parallel response, which manifested itself as a consuming interest in the natural world as God's creation. Only toward the end of the fifteenth century did northern art draw close to the Italian renaissance in the figure of Albrecht Dürer of Nuremberg, which was one of the first centers of humanism in Germany. He initiated what can only be called the high renaissance in the north, for his art partakes of the same lofty spirit as Leonardo's and Raphael's.

Unlike Dürer, Lucas Cranach never visited Italy and only indirectly felt the impact of classicism, though he was well versed in humanistic learning. Instead, he became an early convert to Protestantism and a close friend of Martin Luther. He nevertheless accepted commissions from Catholic patrons and sometimes turned to Dürer's prints for inspiration.

Cardinal Albrecht of Brandenburg as St. Jerome shows Luther's principal foe. The panel was executed by a member of Cranach's large shop (perhaps his son Hans) from his design and is similar to one in the Hessisches Landesmuseum, Darmstadt. Like Cranach's other portraits of this sitter, it is based on an engraving by Dürer. The composition is furthermore a virtual mirror image of Dürer's famous print of St. Jerome in his study, which is shown here as a contemporary room complete with a chandelier called a *Lusterweibchen*. (A similar chandelier hangs above the picture in the gallery.)

To Albrecht, a humanist who corresponded with Erasmus and patronized the rabid anti-Lutheran Ulrich von Hutten, St. Jerome was the epitome of the religious scholar, having translated the Bible into the Vulgate. The lion that was Jerome's companion in the wilderness announces Albrecht's identification with the great saint. In keeping with humanism, the painting has an elaborate symbolic program, which allows several interpretations. Suffice it to say that the beaver, for example, is an emblem of industriousness and constancy, the pheasant and peacock of immortality and redemption. The apple in turn represents original sin, the pear Christ incarnate.

Signed and dated l.l.: dragon emblem 15|2|6

Provenance: Ducal collection of Sahlzdahlen, sold 1811; Rat Hollandt, Brunswick, 1851; Oberst von Natzmer, Potsdam, 1900; Schröder, Melzen, 1925; P. Cassirer Gallery, Berlin, 1926; John Ringling, 1932.

Selected bibliography: M. Friedländer and J. Rosenberg, *Die Gemälde von Lucas Cranach*, Berlin, 1932, fig. 158; rev. ed. *The Paintings of Lucas Cranach*, New York, 1978, p. 106, no. 186; E. Panofsky, *The Life and Art of Albrecht Dürer*, Princeton, 1955, pp. 154-155; E. Ruhmer, *Cranach*, London, 1963, p. 84, no. 21; K.-H. Klingenberg, *Gestaltung in der Renaissance*, Berlin, 1970, p. 136, pl. 54; D. Koepplin and T. Falk, *Lukas Cranach*, Basel, 1974, I, p. 101, no. 12; H. Friedman, *A Bestiary for St. Jerome*, Washington, D.C., 1980, pp. 104-135, fig. 107; J. de Coo, "A Medieval Look at the Merode Annunciation," *Zeitschrift für Kunstgeschichte*, 1981, p. 126, fig. 25.

Selected exhibitions: *Pictures Within Pictures*, City Art Museum, St. Louis, 1949; *Holbein and His Contemporaries*, John Herron Art Institute, Indianapolis, 1950; *Renaissance Portraits*, Smith College, Southampton, 1953; *Masterpieces of Art*, Los Angeles County Museum of Art, 1957; Wildenstein, no. 14.

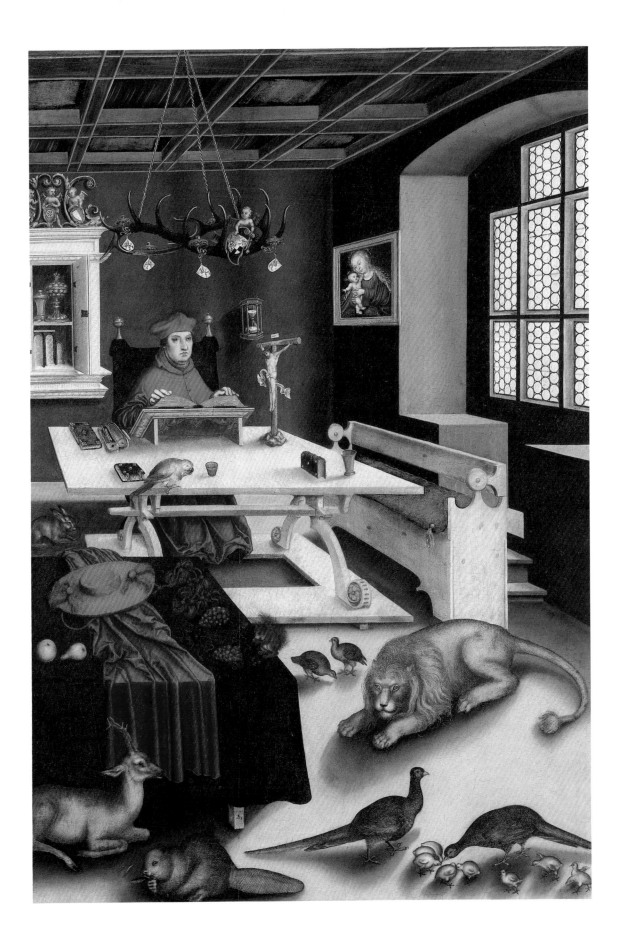

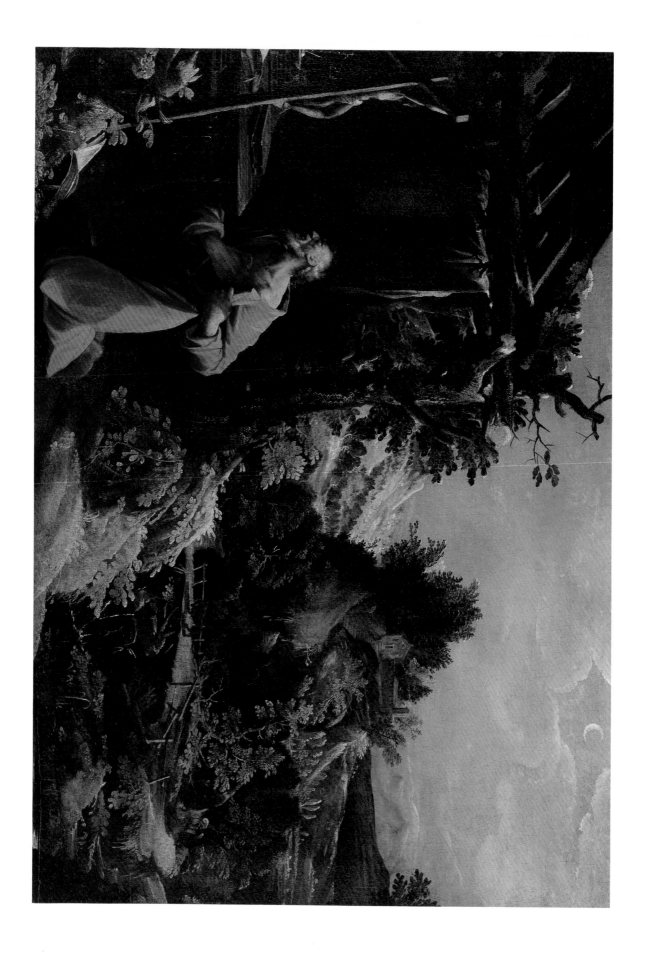

Paul Bril
Flemish, 1554-1626
ST. JEROME IN THE WILDERNESS, c. 1595-1600
oil on canvas, 35 x 49 5/8. SN 707

Though a Fleming by birth and training, Bril was inspired by his brother Matthew's success to settle in Rome at the age of twenty. They collaborated on landscape frescoes in the Vatican, and Bril continued in this specialty for some two decades after Matthew's death in 1583. *St. Jerome in the Wilderness* can be placed between 1595, the year of his first dated oil, and 1600, when he began painting the Arcadian landscapes populated by shepherds or cowherds tending their flocks, sometimes by mythological figures, for which he became famous. This makes it an early, though by no means youthful, masterpiece. The canvas is indebted to his brother, as well as to north Italian landscape painters, notably Girolamo Muziano, who in turn had been influenced by the Flemish mannerist tradition. The painting is unusual in the artist's oeuvre. Whereas his other works of this period are generally tempestuous, *St. Jerome in the Wilderness* has a quiet drama that is no less intense. The subject, rare in the North, was well established in Italian art. Depicting it as a nocturne seems to have been an innovation introduced by Bril. Unlike those in his other landscapes, the figure here is not an afterthought but the key element. The saint's red mantle rivets the eye and expresses his religious ardor as he prays before the crucifix. The moonlit landscape evokes the hermit's isolation from the world with haunting effect. Dimly visible in the middle distance is the lion who became Jerome's companion.

Signed l.l.: PB

Provenance: Frederick Mont Gallery, New York, acquired 1959.

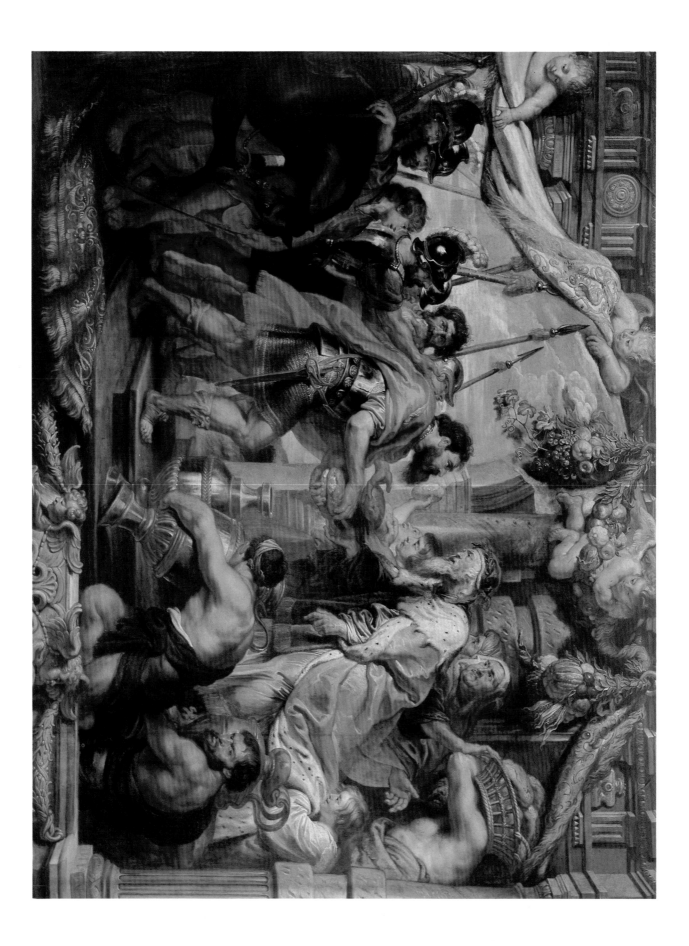

Peter Paul Rubens

Flemish, 1577-1640
THE GATHERING OF THE MANNA, c. 1625
oil on canvas, 192 x 162. SN 211
ABRAHAM AND MELCHIZEDEK, c. 1625
oil on canvas, 175 1/4 x 224 3/4. SN 212
THE FOUR EVANGELISTS, c. 1625
oil on canvas, 173 x 176. SN 213
THE DEFENDERS OF THE EUCHARIST, c. 1625
oil on canvas, 171 x 175. SN 214
THE TRIUMPH OF DIVINE LOVE, c. 1625
oil on canvas, 152 1/2 x 204. SN 977

Rubens and the Italian sculptor Gianlorenzo Bernini were the greatest artists of the 17th century. Rubens's epic canvases defined the scope and style of high baroque painting. They possess a seemingly boundless energy and inventiveness. In his life as well, Rubens epitomized the extroverted ideal of baroque man, that of the virtuoso for whom the entire universe is his stage. On the one hand, he was a devoutly religious person and, on the other, a man of the world who succeeded in every arena by virtue of his character and ability. Rubens resolved the contradictions of the era through humanism, that union of faith and learning attacked by the Reformation and Counter-Reformation.

Rubens's genius found consummate expression in his designs for The Triumph of the Eucharist tapestries. The Eucharist as the embodiment of Christ was central to the rift between Catholicism and Protestantism. Thus, the reaffirmation of traditional dogma in this cycle signifies the victory of the Counter-Reformation over the heresies posed by Luther and his followers. The Catholic church responded to the challenge of Protestantism by rededicating itself to missionary, educational and charitable work as part of a life of religious observance and self-sacrifice. By 1580 the tide of the Reformation had been stemmed, and at the turn of the century the Roman Church was once again firmly established in Flanders.

Like the rest of the Hapsburg rulers of Spain and the Netherlands, the Archduchess Isabella Clara Eugenia was an ardent Catholic who supported the Counter-Reformation. She commissioned The Triumph of the Eucharist from Rubens around 1625. Upon their completion three years later, the Archduchess donated the tapestries to the Carmelite convent of Las Descalzas Reales in Madrid, where they still hang in the chapel. (Partial replicas are in Cologne and Geneva.) There are eleven major scenes which, with an equal number of lesser ones, comprise the tapestries. Although their exact arrangement has been debated, the series forms a coherent symbolic program: four Old Testament prefigurations (including *The Gathering of the Manna* and *Abraham and Melchizedek*), two scenes representing allegorical victories over paganism and heresy, another two of *The Four Evangelists* and *The Defenders of the Eucharist*, and three triumphal processions, among them *The Triumph of Divine Love*. Rubens has treated them as tapestries within tapestries, each surrounded by an illusionistic architectural framework. This device elides the distinction between the real and the divine, in order to establish the allegorical intent. Because the compositions were transferred to the back of the tapestries for weaving, they are seen in reverse.

The Triumph of the Eucharist constitutes the third of Rubens's four tapestry series. (The others are The History of Decius Mus, 1617; The History of the Emperor Constantine, 1622-1623; and The History of Achilles, 1630-1635). In working on The Triumph of the Eucharist, the artist followed his usual practice of first painting various *bozzetti*, or oil sketches, of each subject, probably with the aid of drawings. Then came several *modelli*, or models; the final one, sometimes executed in large part by a studio assistant, served as the basis for the full-scale cartoon, which rarely shows any significant departures. As with the Decius Mus tapestries, the cartoons are oil on canvas, instead of the standard tempera on paper glued to canvas. They may have been done this

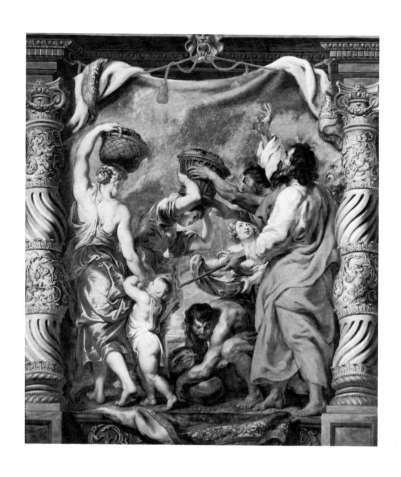

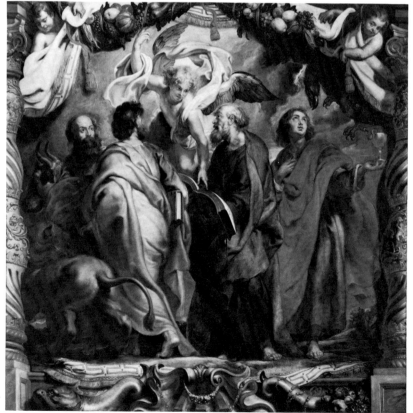

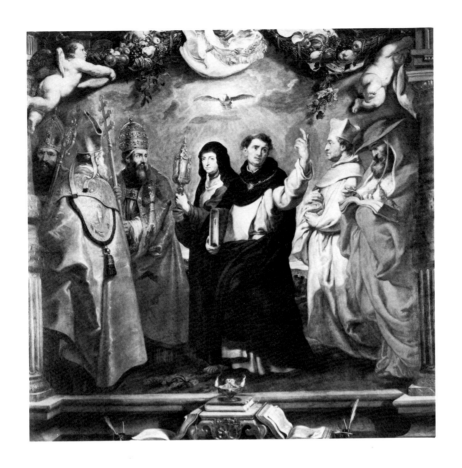

way so that Isabella could enjoy the paintings after the gobelin factory was done making the tapestries — which she would never see — and to prevent duplicate sets from being made from them for other patrons. At least some of the eleven canvases presumably hung in her palace in Brussels, though the precise setting is not known. In 1648, fifteen years after her death, six were sent to the Carmelite church at Loeches near Madrid. Four of them are in the Ringling Museum of Art, while the other two are owned by the Musée des Beaux-Arts, Valenciennes. The early history of *The Triumph of Divine Love*, which is also in Sarasota, is unclear, as is the reason for its different size. The rest were consumed in a fire at the palace in 1731.

As with Rubens's other large projects, such as The Life of Marie de'Medici (Louvre, Paris), The Triumph of the Eucharist cartoons necessarily involved at least several assistants. It is admittedly difficult to separate them out, since they were all working in Rubens's style. Much of the architecture and drapery, however, would appear to be by Theodor van Thulden, while Jan Boeckhorst was seemingly responsible for most of the subsidiary figures. The work must have proceeded rapidly, as there are signs of haste throughout these huge canvases.

Most scholars see little evidence of Rubens's hand. The distinction is perhaps not so important as it seems, because in the seventeenth century products of the shop would have been regarded as his own paintings. It is nevertheless inconceivable that the artist himself did not participate directly in executing a major commission for such an important patron. In fact, his role was more extensive than has generally been acknowledged. He seems to have saved the most significant parts for himself. All the main heads, hands and feet are surely by him. Though roughly painted, they have a sense of life that shows his unique ability to capture the palpable appearance of human flesh with a clear feel for the underlying anatomy. To be sure, some figures remain controversial, notably the blond woman seen from behind in *The Gathering of the Manna*. He probably also retouched portions of the costumes and drapery. *The Triumph of Divine Love* shows the fewest signs of his intervention, which is confined largely to the eros riding the delightfully ferocious lion. Such controversies aside, The Triumph of the Eucharist represents one of Rubens's most impressive achievements, and the cartoons are rightly regarded as the greatest treasures of the Ringling Museum.

Provenance: Infanta Isabella Clara Eugenia, Palace, Brussels; Church of las Descalzas Reales, Leoches, after 1649; taken from the convent c. 1808 by G. Wallis for W. Buchanan; acquired by Courke in Madrid; acquired by Robert, Earl Grosvenor, First Marquess of Westminster, London, 1818; Duke of Westminster sale, Christie, London, July 4, 1924, no. 63 (withdrawn); acquired from Duke's estate by John Ringling, spring, 1925.

The Triumph of Divine Love: Phillips, London, May 11, 1815, lot 63; Christie, London, July 8, 1822, lot 17 (as having "been painted expressly for the Conde Duque de Olivares and deposited by him in the Convent of Leoches"), bought by Joshua Taylor; Taylor sale, Forster, London, July 25, 1835, lot 104, to Mr. Pennel, then to Mr. Cave; Phillips, London, 1841; St. James Gallery of Paintings, acquired by William John Bankes by 1844; then to his heirs; Christie, London, April 2, 1976, lot 3; Ross Galleries, London; Christopher Gibbs, Ltd., London, acquired 1980.

Selected bibliography: J.B. Descamps, *La vie des peintres flamands, allemands et hollandois*, Paris, 1753, I, p. 320; W. Buchanan, *Memoirs of Painting . . .*, London, 1824, II, pp. 219-224, 232-233, 381-382; J. Smith, *A Catalogue Raisonné of the Most Eminent Dutch, Flemish and French Painters*, London, 1830, II, pp. 138-142, no. 504; IX, pp. 296-297, no. 188-193; G. Waagen, *Treasures of Art in Great Britain*, London, 1854, II, pp. 114, 163; M. Rooses, *L'Oeuvre de P.P. Rubens, histoire et description de des tableaux et dessins*, Antwerp, 1886-1892, I, pp. 60-63; E. Tormo, *En las Descalzas Reales, estudios historicos, iconographicos y artisticos, Los tapices: las Apoteosis eucaristica de Rubens*, Madrid, 1945, pp. 38, 44-45; J.S. Held and J.A. Goris, *Rubens in America*, Antwerp, 1947, pp. 48-49, no. A 36; V. H. Elbern, *Peter Paul Rubens, Triumph der Eucharistie, Wandteppiche as dem Kölner Dom*, Essen, 1954-1955, pp. 28, 39; C. Scribner, "Sacred Architecture: Rubens' Eucharist Tapestries," *The Art Bulletin*, LVII, 1975, pp. 591ff.; N. de Poorter, *The Eucharist Series (Corpus Rubenianum Ludwig Burchard, II)*, Brussels, 1978, nos. 7d, 14c, 15d; Wilson, nos. 35-38. C. Scribner, *The Triumph of the Eucharist, Tapestries Designed by Rubens*, Ann Arbor, 1982.

Peter Paul Rubens
Flemish, 1577-1640
PORTRAIT OF THE ARCHDUKE FERDINAND, 1635
oil on canvas, 45 3/4 x 37. SN 626

The Archduke Ferdinand of Austria arrived in Antwerp in April 1635 to assume the governorship of Flanders, which had gone vacant since the death of his aunt, Isabella, two years earlier. Fresh from his victory over the king of Sweden at the battle of Nördlingen the previous November, he was received as a national hero who would restore the waning political and economic fortunes of the country. With its love of artifice, the baroque found perhaps its most characteristic expression in lavish theatrical displays and ceremonies, for which Rubens had a special genius. Accordingly, he was placed in charge of the decorations for the Archduke's triumphant entry into the city, which were produced by a small army of assistants.

After the festivities were over, Ferdinand posed for this painting, which in turn provided the basis for an equestrian portrait of the Archduke at Nördlingen (Prado, Madrid). Ferdinand establishes a direct visual and emotional contact with the viewer. The Ringling painting suggests an unusual rapport between sitter and artist, and no wonder. Rubens's talents extended to diplomacy, and he was entrusted with delicate missions to the leading capitals of Europe on behalf of the Hapsburgs who ruled Flanders — and who were among his best patrons.

For this painting, Rubens turned to Titian for prototypes. To be sure, he was hardly the first to do so. For example, Anthonis Mor, a Flemish portraitist who had likewise worked for the Spanish court, earlier used Titian as a source. Rubens, however, did so from a fundamentally different point of view. It was Titian who, more than any other artist, influenced Rubens's brushwork and color. Moreover, Rubens had a keen appreciation of the role played by history painting in forming Titian's portraiture. He realized early on that, unlike a portrait specialist, Titian was able to express nobility through form, pose and setting, as well as psychological characterization, making his among the most penetrating of portraits.

Titian defined the military portrait in *General Francesco della Rovere* (c. 1536-1538, Uffizi, Florence). Rubens had already adopted this example with little variation five years before in *Thomas Howard, Second Earl of Arundel* (Isabella Stewart Gardner Museum, Boston). The artist met Howard, the first great English art collector, during negotiations at the Court of St. James, and it is clear in this forceful portrait that they shared mutual interests and a high esteem for one another. As an official state portrait, however, the painting of Ferdinand served a different purpose. To signify his office, the Archduke is shown wearing the felt hat of governor, with a swag of drapery in the background referring to the ruler's state canopy of Roman times. At the same time, he wears armor and reveals an elaborate sword at his side while holding a general's baton to show him as defender of the state. Ferdinand is, then, both a military and a civic leader who has put aside the helmet of war for the hat of office.

This dual capacity required that Rubens introduce a second type that gives a new meaning to the Archduke's portrait: the courtier-diplomat, which has also been codified by Titian in *Antoine de Granvelle* (1548, Kansas City Art Museum) and *The Duke of Alba* (c. 1548-1549, known only through an engraving after Rubens's copy, which is also lost!). They are distinguished from General della Rovere's picture by the more open, idealized treatment of their faces. Rubens clearly understood the different intent, for he has handled Ferdinand's features in these very terms. In uniting the two portrait types, Rubens has reinterpreted them, so that the Archduke emerges as a dashing, handsome young man. Tragically, he was to live only six more years.

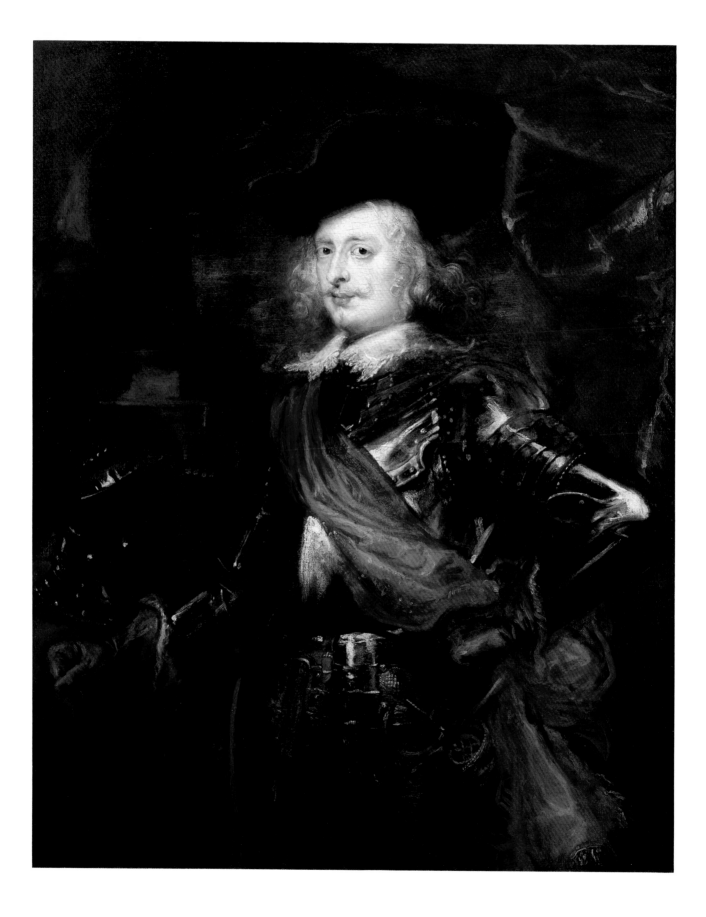

Provenance: Sir Joshua Reynolds, 1771; The Earl of Upper Ossory; Robert Vernon, First Baron Lyveden; The Hon. Greville Richard Vernon; J. Pierpont Morgan, London, 1898; Knoedler Gallery, New York; John Ringling.

Selected bibliography: J. Smith, *A Catalogue Raisonné of the Works of the Most Eminent Dutch, Flemish and French Painters*, London, 1830, II, no. 917; R. Oldenbourg, *P. P. Rubens, Des Meisters Gemälde*, Klassiker der Kunst, Stuttgart and Berlin, 1921, p. 376; J.S. Held and J.A. Goris, *Rubens in America*, New York, 1947, p. 26, no. 3; E. Larsen, *P. P. Rubens*, Antwerp, 1952, p. 219; J.R. Martin, *The Decorations for the Pompa Introitus Ferdinandi (Corpus Rubenianum Ludwig Burchard, XVI)*, London and New York, 1972, pp. 152-153, no. 39; Wilson, no. 34. F. Baudouin, *P. P. Rubens*, Antwerp, 1977, p. 273, fig. 140.

Selected exhibitions: *Loan Exhibition of Painting by Rubens and Van Dyck*, Los Angeles County Museum of Art, 1946, no. 37; *P. P. Rubens*, Royal Museum of Fine Arts, Antwerp, 1977, no. 94; Wildenstein, no. 44.

Anthony van Dyck
Flemish, 1599-1641
ST. ANDREW, 1621
oil on panel, 25 1/2 x 20 1/4. SN 227

While he was serving Rubens as a studio assistant in 1615-1618, Van Dyck had already begun painting individual pictures of the apostles. He later repeated them, sometimes in several versions. *St. Andrew* is from the Böhler series of apostles (named for the Munich art dealer who discovered them in 1914), one of two sets he is known to have assembled and the only one that survived intact. It was one of a group done during the seven months in 1621 after the artist returned to Antwerp from his first visit to London and before he went to Italy. It is nearly identical to one in the Ponce Museum of c. 1618-1620, which may well have belonged to the first set.

Like other apostles by Van Dyck, it follows the example set by Rubens in his paintings of saints. Such images had a long history in the north going back to gothic art. Rubens, however, treated them with unprecedented monumentality. In treating them, Van Dyck did not merely imitate Rubens, but reinterpreted his exemplars with considerable independence.

Of all Van Dyck's saints, Andrew is special for the sensitivity and introspection of the characterization. His rough-hewn face and hands suggest the inner strength of his faith, for which he died on the cross he is holding. The painting is equally notable for its vigorous brushwork. The young Van Dyck (he was all of twenty-two at the time) revelled in his sheer ability to handle paint. Early works like this have a seemingly cavalier disregard for finish resulting from a lack of discipline, but the rawness of the surface is more than made up for by its expressive immediacy.

Provenance: Palazzo Rosso, Genoa, early eighteenth century; Giambattista Serra, Palazzo Serra, Genoa, 1766; private collection (possibly Donna Giulia Serra), Naples; Julius Böhler Gallery, Munich, c. 1914; Madame Godfrey Brauer, Nice, 1915; Brauer Sale, Christie, London, July 5, 1929, no. 42.

Selected bibliography: *Descrizione della Galleria de quadri esistenti nel Palazzo del Serenissimo Doge Gio Francesco Brignole Sale,* Genoa 1748; G. Glück, "Van Dycks Apostelfolge," *Festschrift für Max J. Friedländer,* Leipzig, 1927, p. 142; H. Rosenbaum, *Der Junge Van Dyck,* Munich, 1928, pp. 37, 44; G. Glück, *Rubens, Van Dyck und ihr Kreis,* Vienna, 1933, p. 290; Wilson, no. 14; M. Roland, "Some Thoughts on van Dyck's Apostle Series," *Essays on Van Dyck,* Ottawa, 1983, pp. 23ff.

Exhibition: *The Young Van Dyck,* National Gallery of Canada, Ottawa, 1980, no. 9.

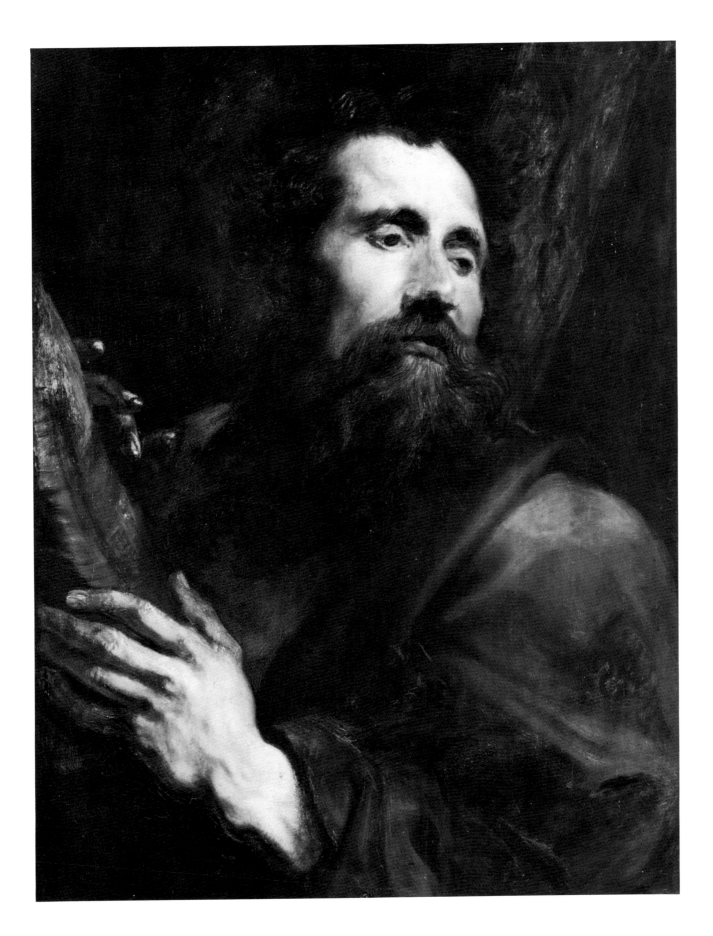

Jacob Jordaens
Flemish, 1593-1678
BOAZ
RUTH AND NAOMI, c. 1641-1642
oil on canvas, 76 5/8 x 30 1/2 each. SN 987, 988

At his best, Jacob Jordaens was fully the equal of Rubens and Van Dyck, and upon their deaths succeeded them as the premier painter of Flanders. Although he is known for his crowded tableaux, *Boaz* and *Ruth and Naomi* demonstrate what Jordaens could achieve when he devoted his full attention to a few monumental figures. These exceptionally strong, well-preserved pictures are entirely by the artist's own hand. They can be dated to 1641-1642 on the basis of style and were probably done to decorate the artist's house, which was built at that time. The paintings would have been hung high up between two windows or flanking a central doorway. The religious subject would not have been out of keeping in this context, for among other decorations, which are known to have been extensive, was a series of prophets.

The subject is taken from the Book of Ruth. After the death of her husband and children, Naomi and her daughter-in-law, the Maobitess Ruth, return to Bethelehem at the beginning of harvest time and seek the protection of her kinsman, Boaz. Jordaens depicts Boaz at the moment when he acquires the land of Naomi's husband from her next-of-kin and, with it, Ruth as his wife. It was the custom of the day for a man to pull off his shoe and give it to the older man as a sign of attestation whenever property was redeemed or exchanged. In the other panel, Ruth shows Naomi the barley that Boaz has given her after she slept with him at Naomi's behest. From Rubens on, Flemish artists invested their figures with a vigor bespeaking a zest for life that remains a most appealing ideal. The masterful characterizations seen here exemplify Jordaens at his best. Boaz is shown, despite his age, as powerful and determined. Ruth is appropriately voluptuous, yet virtuous, while Naomi is portrayed as the wily schemer she was.

Like other equally piquant episodes from the Old Testament, the story of Ruth and Boaz is traditionally interpreted as a sign that God protects the faithful and as a beneficent act in reward of virtue. There is another level of meaning as well: Ruth and Boaz were direct ancestors of Christ, for their son, Obed, was the grandfather of David, from whom Jesus was descended. The story of Ruth parallels that of the Virgin, her lineal descendant, and St. Anne, both of whom likewise married much older men. They are the subject of a Visitation (Musée des Beaux-Arts, Lyons) which is documented in 1642. The paintings of Ruth and Boaz were also done shortly after two others that pursue the theme of the "Ill-Assorted Couple," popular in northern art since the early sixteenth century (Stanley S. Wule, Philadelphia; formerly Rosenberg and Stiebel, New York). The Biblical story was very likely attractive to Jordaens as a more virtuous example of this moralizing but risqué subject.

Provenance: Stier d'Aertselaer Collection, Antwerp (sold at auction 1817); Count Stenbock, Stockholm, 1929; Colnaghi, New York, acquired 1984.

Bibliography: M. Rooses, *Jacob Jordaens*, London, 1908, p. 252; L. van Puyvelde, *Jordaens*, Paris, 1953, p. 186.

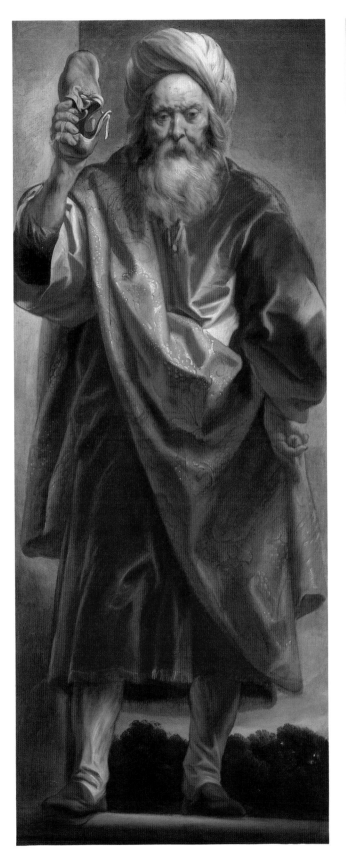

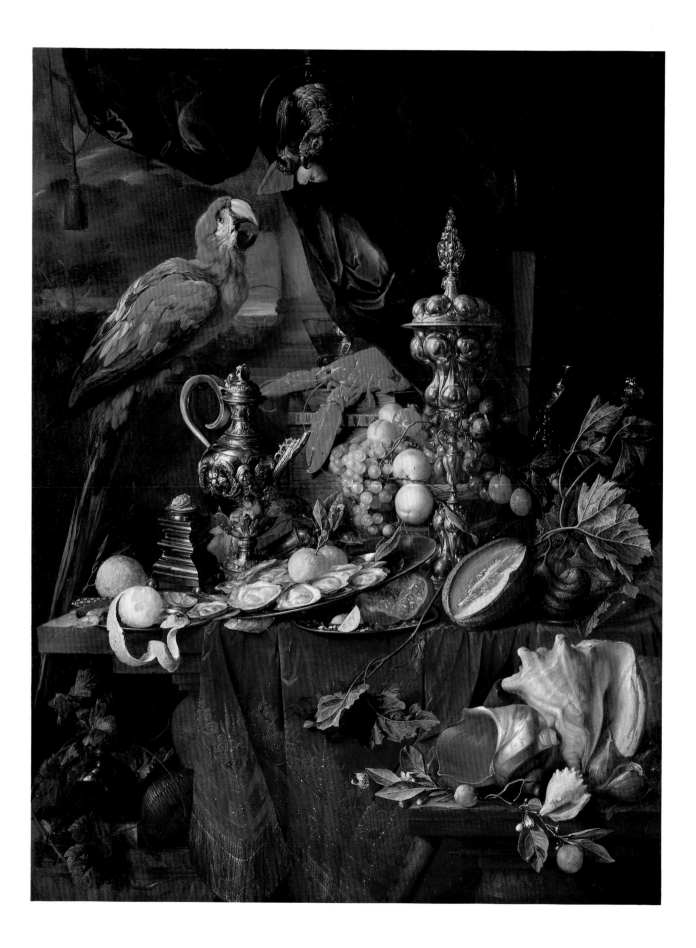

Jan Davidsz. de Heem

Dutch-Flemish, 1606-1684
STILL LIFE WITH PARROTS, late 1640s
oil on canvas, 59 1/4 x 45 1/2. SN 298

De Heem began his career in Leiden painting Vanitas still lifes, which admonish the viewer to remember the transience of life and the worthlessness of earthly pleasures. In 1635 he moved to Antwerp, where he remained for the rest of his life except for a few years in Utrecht during the early 1670s. De Heem's achievement was to synthesize the flamboyant Flemish tradition of Frans Snyders and Adriaen van Utrecht with the Dutch "pronk," or fancy, still life into a unique style that proved extremely influential in both countries. His mature manner was formed in the years 1640-1642 and varied but little thereafter.

Still Life with Parrots is an exceptional example of his work from the end of that decade. Antwerp was famous for having exotic fruits, birds, animals, and objects from around the world. These and other luxuries have been compiled by De Heem in a stunning tour de force. Despite the profusion, the composition is carefully balanced and the color tightly controlled to unify the picture. It is tempting to see in this extravagant display a hidden admonition by way of example to be temperate. Though consistent with the artist's Dutch background, such a moral message would have been out of keeping with the appetitive theme of abundance in Flemish art. Many of the objects in *Still Life with Parrots* do, in fact, have emblematic meaning, but the painting has no coherent symbolic program. In the end, the viewer is simply meant to enjoy the visual feast.

Signed l.r.: F.D.De Heem. f

Provenance: Counts of Schönborn, Pommerfelden; Pommerfelden sale, Paris, May 17-24, 1867, no. 38; John Ringling.

Bibliography: Suida, no. 298; Wilson, no. 84.

Selected exhibitions: *Fêtes de Palette*, Delgado Museum, New Orleans, 1962; *Masterpieces from Southern Museums*, Norfolk Museum, 1969; Wildenstein no. 33.

Piero di Cosimo
Italian, c. 1462-1521
THE BUILDING OF A PALACE, c. 1515-1520
oil on panel, 32 1/2 x 77 1/2. SN 22

Piero di Cosimo occupies a singular niche in the history of renaissance painting in Florence. About half of his work consists of religious subjects, some of great beauty, which show the influence of his contemporaries, from Sandro Botticelli to Fra Bartolommeo and his own pupil, Andrea del Sarto. But it is for his mythological scenes that he is justly known. They reveal an ingenious, even humorous, cast of mind that expressed itself through a naturalistic style. *The Building of a Palace* is unique among Piero's paintings in showing the present, not the past. It provides a fascinating view of contemporary building practices that is remarkably true to life.

The attribution of this unusual panel to Piero, though occasionally disputed in the past, is now generally accepted. It nevertheless remains a problematic work. A date around 1507 has been proposed and, indeed, the painting seems close to *The Discovery of Honey* (Worcester Art Museum) and *The Misadventure of Silenus* (Fogg Art Museum, Cambridge) of about that time. The panel must have been done a good ten years later, however. The style is deliberately archaizing, the technique sparer and more linear. The poses of the spindly figures, too, are more rigid and exaggerated. Finally, the composition has the symmetry found in Piero's works toward the end of his career. The late date is confirmed by the balustrade statues, which were first introduced in Verona in 1515.

The subject has given rise to a good deal of speculation. Several references to the panel that have been discovered recently by Sylvia Mascalchi in the inventories of Cardinal Giancarlo de' Medici between 1637 and 1663 do little more than support the traditional title. All attempts thus far to connect it thematically to Piero's known paintings have proved unconvincing, mainly because they assume a weightier content than his pictorial approach could sustain. Nevertheless, there can be little doubt that it must have an allegorical meaning. Like his mythological paintings, it presumably centers on a humanist program. The harmonious architectural design, systematic perspective, and axial symmetry observe the principles of Alberti. The classicizing style of the building itself further shows the influence of Giuliano da San Gallo, the leading architect in Florence during the 1480s. The two were close friends, and the artist painted portraits of him and his father around 1500-1505 (Rijksmuseum, Amsterdam). Contrary to what has been suggested, however, neither the Villa Medici at Poggio a Caiano, nor any other prototype by San Gallo served as the basis for Piero's design. Indeed, it cannot be identified with any known project, despite its detailed description. It is instead a manifestly idiosyncratic and visionary structure of an outmoded late fifteenth-century type. Hence, we need not see in this painting a reminiscence of a Golden Age, a memorial to San Gallo, an extended metaphor of the Medici, or a tribute to their support of humanist learning. Rather, it should be interpreted as a generalized pictorial treatise on the humanists' concept of architecture. To them, architecture was a combination of philosophy, mathematics, and archaeology. It investigated the laws of divine order through the study of harmonious proportion and ideal beauty as embodied in the systems of classical antiquity.

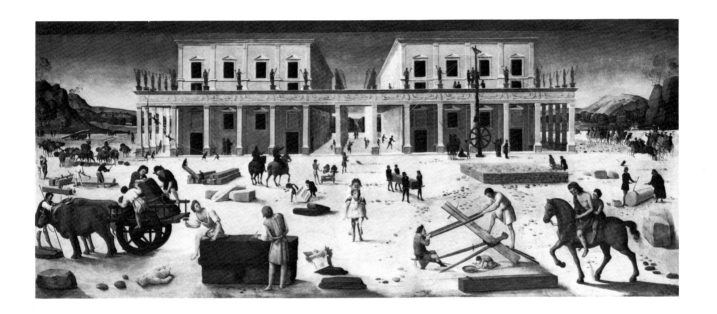

Provenance: Mussim Pouschkine, 1836; Meazza, Milan; Sambon sale, Milan, April 15, 1884, no. 61; Emile Gavet, Paris; William K. Vanderbilt, New York; inherited by Mrs. Oliver Belmont, Newport, R.I.; Duveen, London, acquired John Ringling c. 1928-1929.

Bibliography: L. Douglas, *Piero di Cosimo*, Chicago, 1946, p. 117; Suida, no. 22; P. Morselli, "Ragioni di un pittore fiorentino, Piero di Cosimo," *L'Arte*, 1957, p. 149, pl. 24, *L'Arte*, 1958, p. 49; F. Zeri, "Rivendendo Piero di Cosimo," *Paragone*, 115, 1959, p. 44; L. Grassi, *Piero di Cosimo e il problema della conversione al'500 nella pittura fiorentina ed emiliana*, Rome, 1963, p. 78; B. Berenson, *Italian Pictures of the Renaissance, Florentine School*, London, 1963, I, p. 176; E. P. Fahy, "Some later works of Piero di Cosimo," *Gazette des Beaux-Arts*, 1965, p. 206; M. Bacci, *Piero di Cosimo*, Milan, 1966, pp. 75, 104-105, no. 54, pl. 54; B. Frederickson and F. Zeri, *Census of Pre-Nineteenth Century Italian Paintings in North American Public Collections*, Cambridge, Mass., 1972, p. 164; Tomory, no. 8; M. Bacci, *L'opera completa di Piero di Cosimo*, Milan, 1976, p. 96, no. 54, pls. LII-LIII; G. A. Brucker, *L'Impero del Fiorino*, Florence, 1983, pp. 218-219.

Exhibitions: *Architecture in Early Renaissance Paintings*, Allen Memorial Art Museum, Oberlin, 1955, no. 8; Wildenstein, no. 13.

Gaudenzio Ferrari
Italian, c. 1480-1546
THE HOLY FAMILY WITH A DONOR, late 1520s
oil on panel, 60 1/2 x 45 1/2. SN 41

Ferrari studied in Milan in the late 1490s, before Leonardo da Vinci had left the city, but assimilated the master's style mainly through his pupil Bernardo Luini, with whom he formed a lifelong friendship. Ferrari lived most of his working life in Varallo, and carved out a successful career in provincial centers around Lombardy and the Piedmont. In 1539, he returned to Milan, where he became the dean of painters and served as an important link to the Leonardesque tradition. Though he had only eight more years to live, he provided the chief example for the next generation of Lombard artists through his disciple Bernardino Lanino.

Despite his training, Ferrari's early style was derived principally from fifteenth-century Venetian painting from Andrea Mantegna through Giovanni Bellini. By the 1520s, however, he was able to interpret the high renaissance in strongly individual terms. *The Holy Family with a Donor* was probably done toward the end of that decade. The composition exists in a lost replica, which is known through an engraving, and two variants. It develops further a pictorial type defined by the artist in his altar of 1516 in the Collegiata di Santa Maria, Arona, and a similar altar in the Basilica of St. Gaudenzio, Novaro. Intervening between them and this painting is the impact of Correggio. Ferrari may well have seen in him a kindred spirit. Correggio also grew up in a small town and was influenced heavily by Mantegna and Leonardo, as well as the Venetians, but later evolved his own style. At the same time, Ferrari must have recognized Correggio's greater genius. *The Holy Family with a Donor* owes aspects of its forms, landscape, and color to Correggio, without simply imitating him. More important than these stylistic features was the lyrical expressiveness of Correggio. Ferrari's work otherwise reveals a more dramatic, pietistic temperament than seen here. *The Holy Family with a Donor* is one of a series of five great paintings from the late 1520s which were done under Correggio's beneficial influence and which together constitute Ferrari's major achievement as an easel painter. The others include *The Mystic Marriage of St. Catherine* (Duomo, Novaro), *The Flight into Egypt* (Cathedral, Como), *Pietà* (Museum of Fine Arts, Budapest), and *Madonna and Child with Saints* (1529, Church of St. Christopher, Vercelli).

Provenance: Conte Taverna, Milan, until after 1610; Farrer Gallery, London; Robert Holford by 1845; Sir George Holford sale, Christie, July 15, 1927, no. 49.

Selected bibliography: E. Halsey, *Gaudenzio Ferrari*, London, 1904, pp. 86, 133; S. Weber, *Gaudenzio Ferrari*, Strasbourg, 1927, p. 94; Suida, no. 41; A. N. Brizio, "Tre dipinti di Gaudenzio Ferrari," *Studies Dedicated to William E. Suida on His Eightieth Birthday*, New York, 1959, p. 230; V. Viale, *Gaudenzio Ferrari*, Turin, 1968, p. 65, fig. 73, pl. 28; L. Mallé, *Incontri con Gaudenzio*, Turin, 1970, pp. 42, 250, pls. 166-169; B. Frederickson and F. Zeri, *Census of Pre-Nineteenth Century Italian Paintings in North American Public Collections*, Cambridge, Mass., 1972, p. 70; Tomory, no. 43.

Selected exhibitions: *Mostra di Gaudenzio Ferrari*, Turin, May 1956, no. 15; Wildenstein, no. 17.

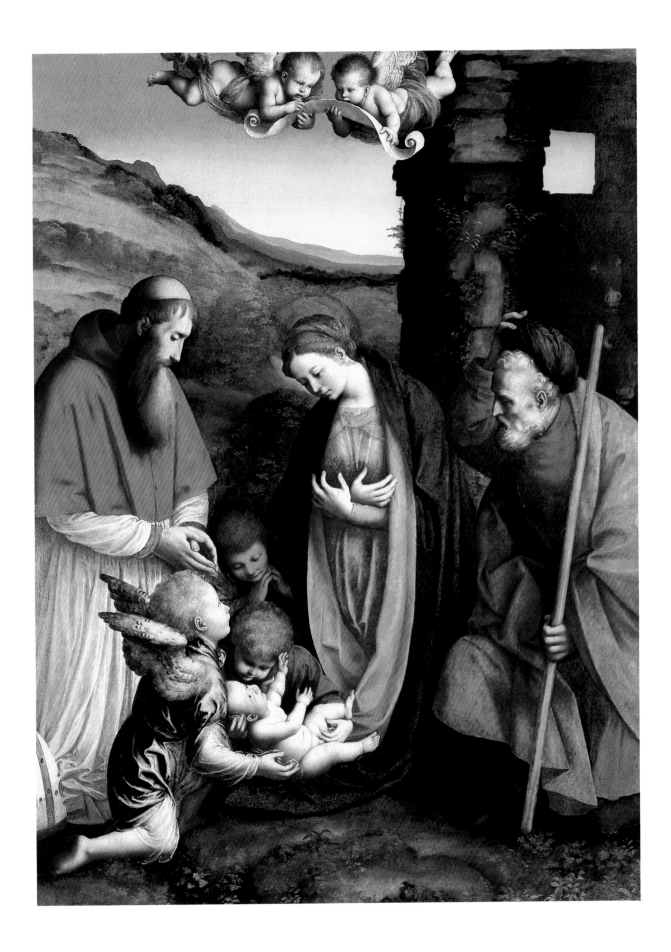

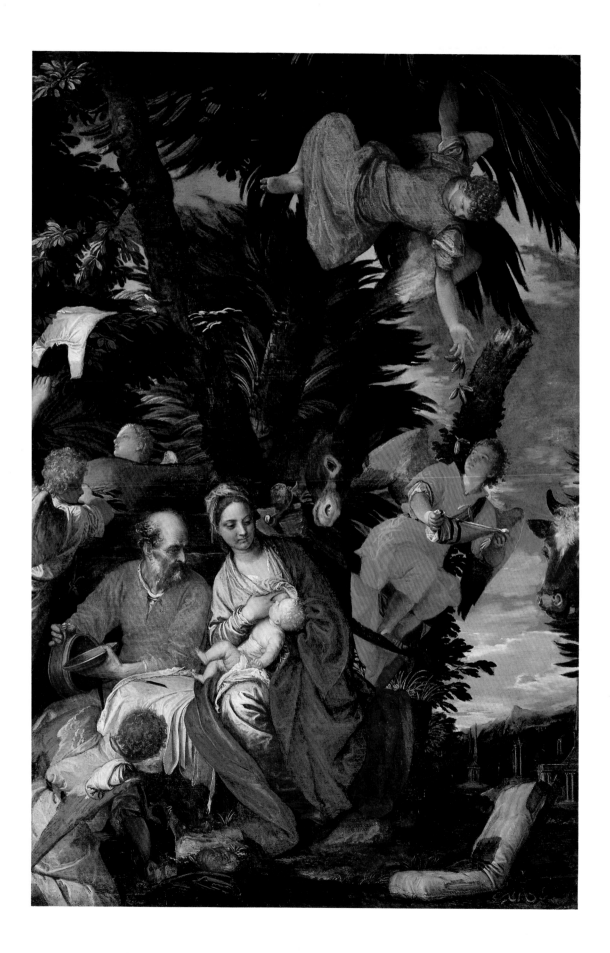

Paolo Veronese (Caliari)
Italian, c. 1528-1588
THE REST ON THE FLIGHT INTO EGYPT, c. 1566-1568
oil on canvas, 92 1/4 x 63 1/4. SN 82

Veronese and Jacopo Tintoretto were the most gifted painters of their generation in Venice. Both were influenced decisively by Titian, who shaped the character of Venetian sixteenth-century art throughout the course of his long career, but with opposite results. Whereas Tintoretto turned to mannerism, Veronese took Titian's grand classicism as his point of departure, while retaining a north Italian devotion to nature. Veronese's contribution to the Venetian tradition was to fuse Titian's *colore* with Michelangelo's *disegno* into a decorative style of sumptuous pageantry.

The Rest on the Flight into Egypt is an enchanting product of Veronese's maturity. From a drawing (Boymans-Van Beuningen Museum, Rotterdam) of it by his son Benedetto bearing account notes from those years, it can be determined that the canvas was done before 1570-1571. *The Rest on the Flight into Egypt* can be dated more specifically to 1566-1568. It accords in spirit with other religious paintings by him of that period, which have an expressive richness to equal their visual splendor. The picture has the vivid colorism and dynamic composition that are the hallmarks of his style. The angels attending the Holy Family lend a festive air to the scene. They are shown gathering dates from the trees, currying the donkey, and even doing the laundry! Their joyous energy radiates pinwheel fashion from the axes of the crossed trees. Anchoring the composition is the tender group of the Madonna nursing her very human Christ child.

The Ringling painting elaborates on ideas explored in two earlier versions of *The Rest on the Flight in Egypt* by the artist (c. 1557, Borletti Collection, Milan; c. 1562, National Gallery of Canada, Ottawa). The germ of Veronese's conception is found in a picture (Prado, Madrid) that, if it is not by Titian, probably emanated from his studio. In addition, he must have had in mind paintings by Jacopo Bassano and Bonifazio Pitati. Veronese adapted the main elements of his composition from Titian's *Death of St. Peter Martyr* (now known only through an engraving). He was also surely inspired by Albrecht Dürer's woodcut of *The Flight into Egypt*, which has a similar donkey in an equally lush tropical setting. Depictions of the Flight into Egypt first became common in Germany in the early 1500s. Dürer's print was executed shortly before his second trip to Venice in 1505-1507, and it helped to popularize the subject there. Though not unknown in earlier art, it was relatively rare, primarily because the only Biblical account of the sojourn in Egypt (Matthew 2:13-14) is so brief that it does not even mention the episode. The Flight into Egypt was, in fact, the invention of Christian mythologists eager to expand on the few references to Jesus's early life.

Signed lower center: PAULI CALIARI VERONESI FACIEBAT

Provenance: Electoral Gallery, Düsseldorf by 1719; Alte Pinakothek, Munich, by 1836; Julius Böhler Gallery, Munich?; acquired John Ringling c. 1925.

Selected bibliography: C. Ridolfi, *Le Meraviglie . . .*, ed. D. von Hadeln, Berlin, 1914-1924, I, p. 322; A Venturi, *Veronese*, Milan, 1928, p. 116; G. Fiocco, *Veronese*, Bologna, 1928, p. 16; idem, *Paolo Veronese*, Rome 1934, p. 197; R. Palluchini, *Veronese*, Bergamo, 1943, p. 49; B. Berenson, *Italian Pictures of the Renaissance, Venetian School*, London, 1957, I, p. 136; T. Tietze-Conrat, review of B. Berenson, *Venetian School, The Art Bulletin*, 40, 1958, p. 347; R. Marini, *L'opera completa del Veronese*, Milan 1968, no. 121; Tomory, no. 124; T. Pignatti, *Veronese*, Venice, 1976, no. 320, fig. 685; R. Gaston, "Bonifazio Veronese's *Rest on the Flight into Egypt*," Bulletin of the Art Gallery of South Australia, 35, 1977, p. 38.

Exhibitions: *Four Centuries of Venetian Painting*, Toledo Museum of Art, 1940; Wildenstein, no. 50.

Sisto Badalocchio
Italian, 1585-after 1620
SUSANNAH AND THE ELDERS, c. 1610
oil on canvas, 63 x 42. SN 111

Susannah and the Elders was accepted until recently as an early painting by Bolognese artist Agostino Carracci. However, laboratory examination shows that the signature A.CARR. BON.F., dimly visible at the lower left, must be a later addition, and the canvas has now been recognized as the work of Sisto Badalocchio. This native of Parma and his friend Giovanni Lanfranco became pupils of Agostino during Carracci's stay there in 1600. Following their master's death two years later, the young artists moved to Rome, where they assisted Agostino's brother, Annibale, on numerous projects. *Susannah and the Elders* was probably done shortly before Annibale's death in 1610. The piquant subject derives from a lost painting of c. 1590 by Annibale, which is known from his own engraving. It proved popular among his followers because it allowed them to treat the nude in dramatic fashion.

Sisto's version shows the full impress of the Carracci, who fused north Italian naturalism and Roman classicism with Venetian colorism to form their baroque style. The round face of Susannah and the sharper features of the elders are indebted specifically to Agostino. The dark sonorities in turn hark back to Annibale's early style, but the emotion-charged expressions and gestures come from his later work. Though it is generic to the school, Sisto's composition has considerable originality and anticipates a very similar one from 1616 by Ludovico Carracci (National Gallery, London). If they seem a bit stiff in the joints, the poses have been carefully calculated for maximum impact, so that the action unfolds almost like a deck of cards. The painting is unusually bold for Sisto, whose work otherwise has the lyricism of the great sixteenth-century Parmese artist Correggio.

Signed l.l. (falsely): A. CAR. BON. F.

Provenance: Villa Aldobrandini, Rome; William Y. Ottley, acquired 1798-1799; Christie, London, May 16, 1801, no. 30; J. Humble sale, Christie, London, April 11, 1812, no. 50; W. Buchanan; Robert Holford, 1846; Sir George Holford sale, Christie, London, July 14, 1927, no. 40.

Selected bibliography: W. Buchanan, *Memoirs of Painting. . .*, London, 1824, I, pp. 2, 25; G. Waagen, *Art Treasures in Great Britain*, London, 1854, II, p. 198; R. Benson, *The Holford Collection*, London, 1927, p. 43, no. 88; Suida, no. 111; P. della Pergola, "Gli Inventare Aldobrandini: l'inventario del 1682(2)," *Arte Antica e Moderna*, 6, 21, 1963, p. 70, no. 247; S. Ostrow, *Agostino Carracci*, dissertation, New York, 1966, pp. 425-427, cat. 2, no. 11, fig. 118; B. Frederickson and F. Zeri, *Census of Pre-Nineteenth Century Italian Paintigs in North American Public Collections*, Cambridge, Mass., 1972, p. 47; Tomory, no. 129; C. van Tuyll, "Badalocchio in America: three new works," *Burlington Magazine*, CXXV, 965, August, 1983, pp. 469-475.

Exhibitions: British Institution, London, 1851, no. 50; *Art in Italy 1600-1750*, Detroit Institute of Arts, 1965, no. 68; *Baroque Art: Era of Elegance*, Denver Art Museum, 1971, p. 12; Wildenstein, no 11.

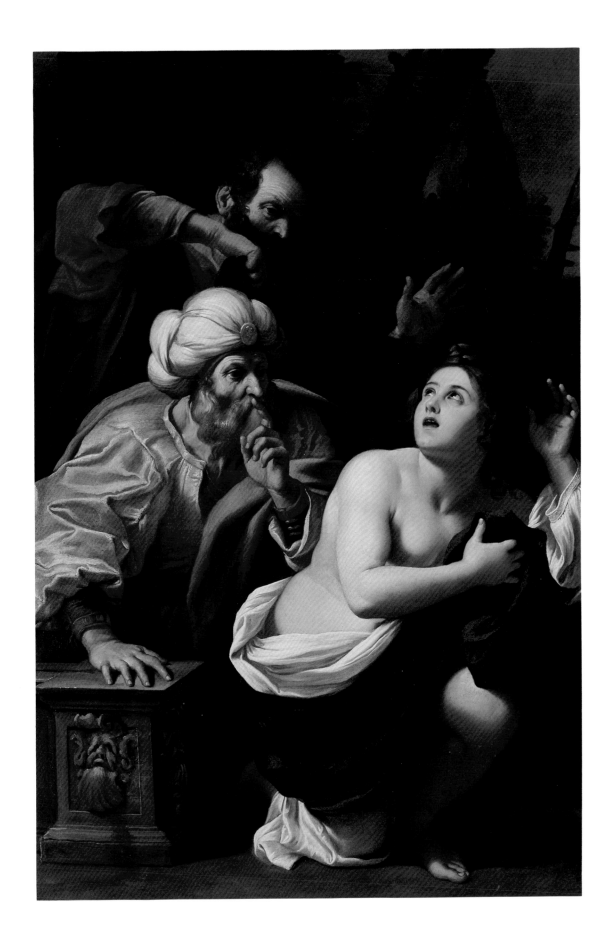

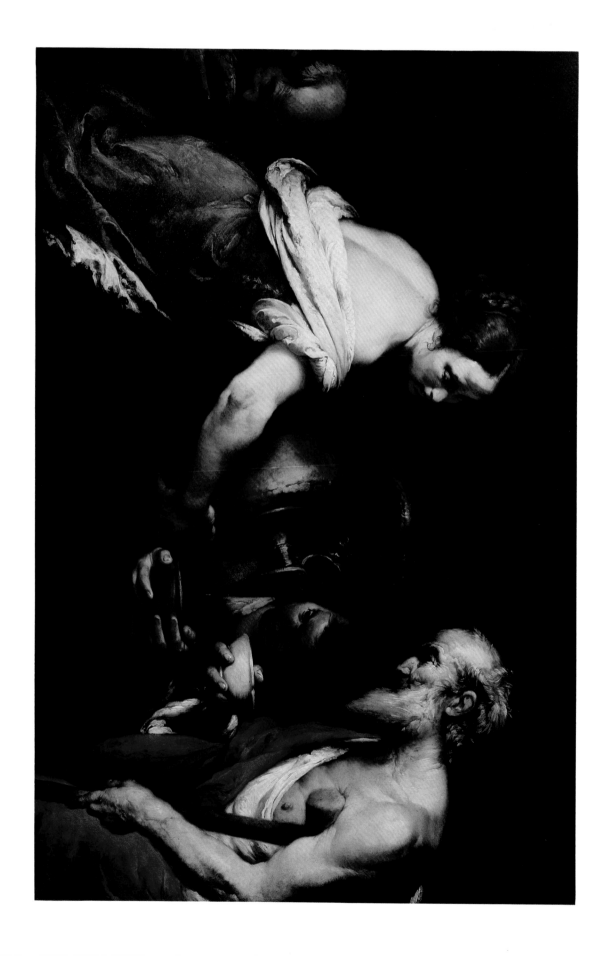

Bernardo Strozzi
Italian, 1581-1644
AN ACT OF MERCY, c. 1616-1618
oil on canvas, 52 1/2 x 74 1/2. SN 634

Strozzi's importance in the history of art lies with his contribution to the painterly tradition in Venice, which he helped to revive after he moved there in 1635. His Genoese paintings, however, are the most consistently satisfying. They show a wide range of influences, from Il Cerano and Giulio Cesare Procaccini in Milan to Rubens and Van Dyck, both of whom worked for the Genoese court. *An Act of Mercy* is an especially fine example from about 1618-1620, when he was under Caravaggio's influence. Strozzi already reveals himself to be a bold colorist in the play between the intense red of the old man's robe and the olive green of the woman's dress. The powerful brushwork does not describe the heroic forms so much as create rivers of paint.

Strozzi often painted repetitions or variants of a theme, particularly early in his career. Four more authentic versions of *An Act of Mercy* are known. (They are owned by J. O'Connor, New York; Marchese Rolandi Ricci, Albenga; the Premoli Collection, Rome; and the E. B. Crocker Art Gallery, Sacramento.) A study for the left arm with the crutch was once with H. Schickman Gallery, New York. Its recurrence testifies to the popularity of this composition with Genoese collectors. Yet the meaning is elusive. The painting is closely related to another painting by Strozzi showing the widow of Sarepta giving water to the prophet Elijah (Kunsthistorisches Museum, Vienna). However, the presence of an extra figure to the left and the similarity of the old man to the beggar in Strozzi's *St. Lawrence Distributing Alms to the Poor* (North Carolina Museum of Art, Raleigh) preclude identifying this as the same subject. Alternatively, it has been suggested that the canvas formed part of the seven acts of mercy; no paintings of the other six acts by Strozzi are known, however. The traditional title, *An Act of Mercy,* is nevertheless justified. The painting is best seen as an exemplary act of charity cast in the guise of a genre scene, without presuming a specific religious content.

Provenance: Fleischauer sale, Stuttgart, April 24-25, 1928?; Bruno Kern; Galerie Sanct Lucas, Vienna, 1937; Oskar Bondy, 1949; Julius Weitzner Gallery, New York, acquired 1950.

Bibliography: L. Mortari, "Sur Bernardo Strozzi," *Bolletino d'Arte*, 1955, p. 332; idem, *Bernardo Strozzi*, Rome, 1966, pp. 89, 155, 167, 172, 174, fig. 186; A. Matteucci, *Bernardo Strozzi*, Milan, 1966, no. 134, pl. 8; B. Frederickson and F. Zeri, *Census of Pre-Nineteenth Century Italian Paintings in North American Public Collections*, Cambridge, Mass., 1972, p. 193; Tomory, no. 62.

Exhibitions: *Bernardo Strozzi in America*, University Art Gallery, Binghamton, 1967, no. 12; Wildenstein, no. 48.

Guercino (Giovanni Francesco Barbieri)
Italian, 1591-1666
THE ANNUNCIATION, 1628-1629
oil on canvas, 77 x 218 (overall). SN 122

The Annunciation was commissioned in 1628 for the sanctuary arch of the Church of Santa Croce in Reggio Emilia by the Confraternità delle Morte and was finished in January of the following year. Although the canvas has suffered in the past, the main features are well preserved. As a result of its location and shape, the canvas posed unusual problems. The artist solved them with considerable ingenuity by removing the scene from its customary interior and showing Mary kneeling instead on the steps of an abstract architectural setting against an expanse of sky. To balance the composition, Guercino painted the angel oversized, so that he fills the left side of the picture. Like Leonardo before him (Uffizi Gallery, Florence), he made effective use of the interval between the figures. The gap serves to carry the divine message from the angel to the Virgin, whose gesture reflects her reception of its import.

The Annunciation is a harmonious expression of the forces that shaped Guercino's mature art. Guercino had closely studied Ludovico Carracci's works in Bologna in 1617. He was no doubt influenced by Ludovico's lunette fresco of *The Annunciation* in the choir of that city's cathedral from around 1606-1609. Even before then, he had begun to develop the dark, painterly manner seen here, which he perfected over the next three years in Ferrara. Guercino was called to Rome in 1621 when his Bolognese patron, Gregory XV, was elevated to the papacy. The frescoes and paintings he executed in the Holy City were of fundamental importance in the development of high baroque art, but by the time he retired to his native town of Cento in 1623, his style had been decidedly tempered by the classicism of Ludovico's cousin, Annibale Carracci. In the Ringling painting, Guercino has subjected Ludovico's *Annunciation* to Annibale's classical logic by placing the composition parallel to the picture plane and taming its baroque dynamism. Classical, too, is the angel seen in the profile and the Virgin's subdued humility. The figures have the rounded fleshiness and idealized features that Guercino introduced into his work around 1622 while still in Rome. There is also a reminiscence of Caravaggio's realism in their physical solidity and dramatic presence. The lyrical mode represented by *The Annunciation* did not endure. After 1630 it gradually gave way to the sentimentality that marks Guercino's response to Guido Reni, whom he succeeded as the head of the Bolognese school in 1644.

Provenance: Confraternità delle Morte, Reggio Emilia; Sir Richard Worsley; Earl of Yarborough, 1804; Christie, London, July 12, 1929, no. 37.

Selected bibliography: G. Waagen, *Art Treasures in Great Britain*, London, 1854, II, p. 87, Supp. p. 66; N. Grimaldi, *Il Guercino*, Bologna, 1968, p. 93; B. Frederickson and F. Zeri, *Census of Pre-Nineteenth Century Italian Paintings in North American Public Collections*, Cambridge, Mass., 1972, p. 99; Tomory, no. 131; D. Sutton, "Aspects of British Collecting, Part II, VII, From Florence to Venice," *Apollo*, December, 1982, pp. 400-401, figs. 21a and b; N. Artiolo and E. Monducci, *Dipinti Reggiani del Bonone e del Guercino*, Reggio Emilia, 1982, no. 16.

Exhibitions: British Institution, London, 1849, no. 2.

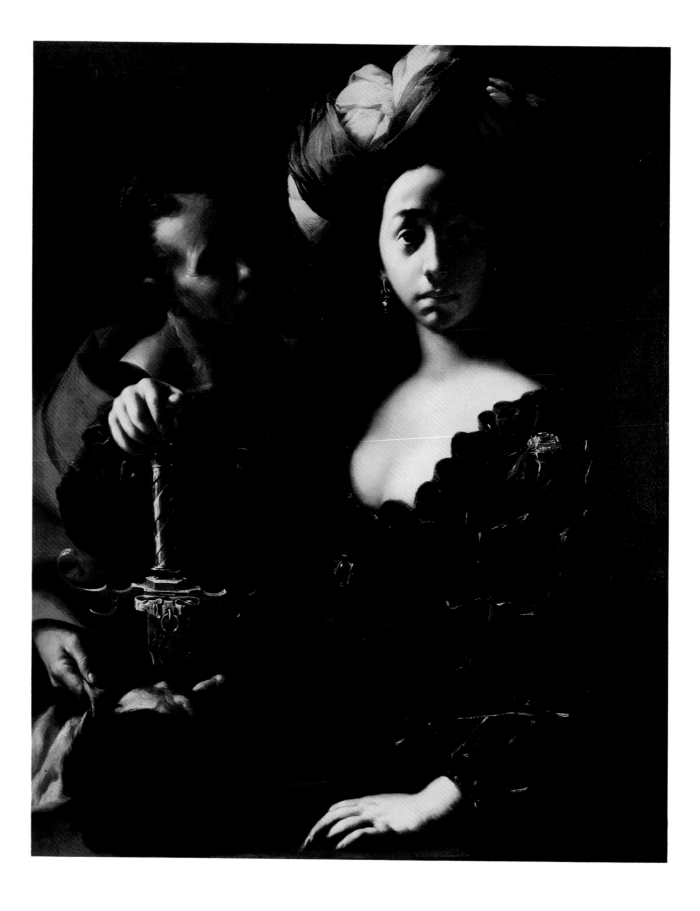

Francesco del Cairo
Italian, 1607-1664
JUDITH WITH THE HEAD OF HOLOFERNES, mid-1630's
oil on canvas, 46 7/8 x 37 1/8. SN 798

Del Cairo's paintings show the fascination with the bizarre that marks the Milanese school, which retained elements of mannerism well into the baroque. His earliest works share the strange expressiveness of Morazzone, under whom he presumably trained. Del Cairo's subjects center on martyrs, swooning saints, and tragic heroines, who are treated with a histrionic intensity reminiscent of his exact contemporary, Artemisia Gentileschi. This penchant for morbid themes and extreme emotions reflects a violent temperament peculiar to the baroque. Much like Caravaggio before him, Del Cairo was involved in a homicide that forced him to flee Lombardy for Turin. There he was knighted in 1632 and became court painter a year later. His best works date from before 1645, when a slackening of inspiration becomes evident; those executed after he settled in Milan three years later are pale imitations of Guido Reni's classical treatment of equally violent subjects.

Judith with the Head of Holofernes, which dates from his first years at Turin, is one of the masterpieces of Del Cairo's career. The story, which comes from the apocryphal book of Judith, 8-13, tells how the beautiful and devout widow saves the Israelite town of Bethulia. After donning her finest clothes, she pretends to defect to the invading Assyrians and then cuts off the head of their general with his own sword as he lies drunk in his tent after a banquet. Del Cairo shows an impassive Judith with the severed head, which her handmaid is about to stuff into a sack and carry back to their people. The gruesome subject was already popular with the preceding generation of painters in Milan. Del Cairo updates the late mannerist style of a canvas from 1596 in the Ringling collections by the Lombard woman artist Fede Galizia into appropriately baroque terms. The compositions are nearly mirror images of each other, but eschewing Galizia's emphasis on surface ornamentation, Del Cairo shrouds the scene in mystery by adopting the dark style of Il Cerano, the most influential Milanese painter of the early seventeenth century. The effect is heightened by a softening of the contours in a Leonardesque haze. The picture achieves a curious sensuousness in the contrast of the whiteness of Judith's flesh against the sea of black. The coloristic accent provided by the exotic turban completes the air of intrigue and seduction.

Provenance: Gunnar A. Sadolin, Copenhagen, c. 1963; Gallery Lasson, London, acquired 1966.
Selected bibliography: P. Cannon-Brookes, *Lombard Paintings c. 1595-c. 1630,* Birmingham Art Gallery, 1974, p. 243, pl. p. 88; Tomory, no. 40; G. A. dell' Acqua, *Francesco Cairo 1607-1665,* Musei Civici de Varese, 1983, pp. 7-8.

Exhibitions: *Baroque Art: Era of Elegance,* Denver Art Museum, 1971, pp. 24-25; *Il Seicento Lombardo,* Milan, 1973, no. 196, pl. 217; Wildenstein, no. 3.

Pietro da Cortona
Italian, 1596-1669
HAGAR AND THE ANGEL, c. 1637
oil on canvas, 45 x 58 3/4. SN 132

Pietro da Cortona occupies a position of central importance in Italian seventeenth-century painting, as he provided the focal point for the rift between the high baroque and baroque classicism. The classicists asserted that art serves a moral purpose and must observe the principles of clarity, unity, and decorum. Supported by a long tradition reaching back to Horace's *ut pictura poesis*, they maintained that painting should follow the example of poetry and tragedy in conveying meaning through a minimum of figures whose movements, gestures, and expressions can be easily read. Cortona, though not anti-classical, presented the case for art as epic poetry, with numerous actors and episodes that elaborate on the central theme and create a magnificent effect. He was also the first to argue that art has a sensuous appeal which exists as an end in itself.

Although the debate took place on a largely theoretical level, it represented divergent approaches to telling a story and expressing ideas in art. In actual practice, the two sides came into conflict over ceiling decorations. Whereas the classicists treated them much like oversized easel paintings, Cortona followed the illusionistic potential implied in the decorations of Veronese and Correggio to its logical conclusion. The differences between easel paintings by Cortona and the classicists are not always so clear cut, however, partly because they shared the same foundations in early baroque art and partly because Cortona himself often sought less radical solutions in this arena. Thus, Cortona's *St. Jerome in the Desert* (c. 1637, Detroit Institute of Arts) is not fundamentally different from the treatment of the same subject (Denis Mahon, London) of some thirty years earlier by Domenichino, Annibale Carracci's most faithful follower.

Hagar and the Angel can be dated just before *The Return of Hagar* of 1638 (Kunsthistorisches Museum, Vienna), which has a similar angel fluttering overhead. The episode is recounted in Genesis 21. The Egyptian bondswoman Hagar and her son Ishmael are cast out at the insistence of Abraham's wife, Sarah, so that Isaac would be Abraham's sole heir; they are saved in the wilderness when the angel calls to Hagar and she awakens to find a well of water. Cortona could claim sanction within the Carracci school for *Hagar and the Angel*, which is close in style and spirit to Francesco Albani's depictions of The Rest on the Flight into Egypt (Suida-Manning Collection, New York; Earl of Yarborough, Brocklesby Park). However, in comparison with works by Andrea Sacchi and Nicholas Poussin, the strictest of the classicists, there is a noticeable lack of rhetoric in *Hagar and the Angel*. Absent, too, is their insistent linearism. Instead, the action is transmitted as a play of graceful, serpentine gestures. While the recumbent Hagar is patently derived from the antique, the balletic pose of the angel recalls Bernini's *Apollo and Daphne* (1622-1625, Galleria Borghese, Rome), one of the masterpieces of baroque sculpture. The blond tonality established by the yellow drapery creates a poetic mood, which is reinforced by the Arcadian setting. *Hagar and the Angel* exists to delight the senses and to please the emotions. Measured in purely aesthetic terms, it is among the most beautiful paintings of the Italian baroque.

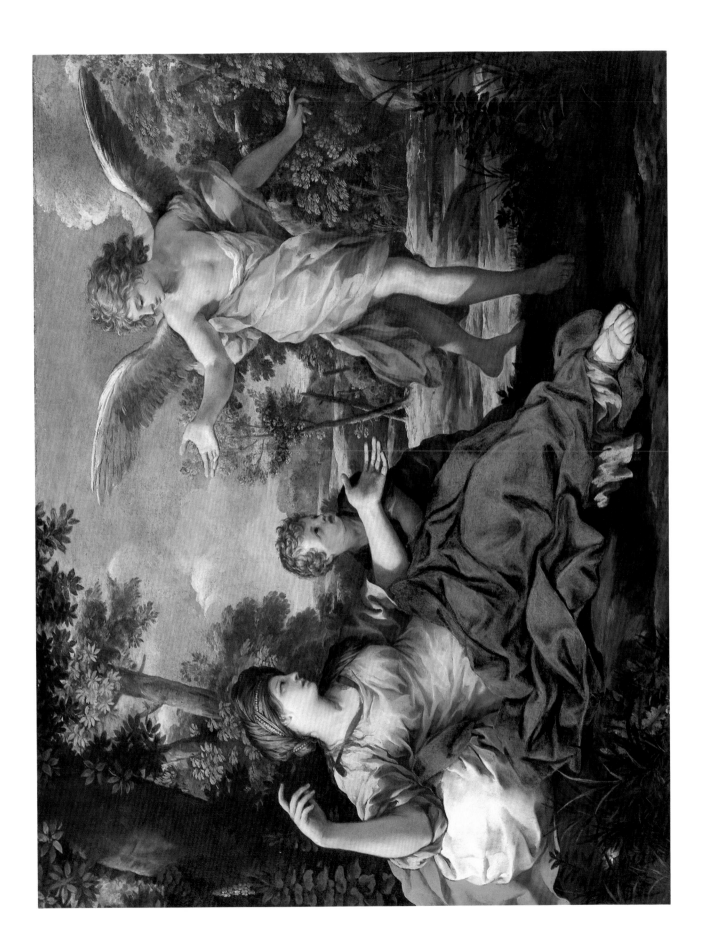

Provenance: Earl Waldegrave; sold Prestage, London, November 16, 1763, no. 45, bought by Brown; Richard, Earl of Grosvenor, First Marquis of Westminster, London; Duke of Westminster; Christie, London, July 4, 1924, no. 9; with Hibbard Gallery, London; Sotheby, London, June 30, 1926, no. 44; Christie, London, May 9, 1930, no. 143; Vitale Bloch Gallery.

Selected bibliography: G. Waagen, *Art Treasures in Great Britain*, London, 1854, II, p. 170; H. Voss, *Die Malerei des Barock in Rom*, Berlin, 1924, p. 544, pl. p. 260; T. Fokker, *Roman Baroque Art, The History of a Style*, Oxford, 1938, I, pp. 232-233, II, pl. 176; Suida, no. 132; G. Briganti, *Pietro da Cortona*, Florence, 1962, pp. 219-220, no. 75, p. 182; B. Frederickson and F. Zeri, *Census of Pre-Nineteenth Century Italian Paintings in North American Public Collections*, Cambridge, Mass., 1972, p. 165; Tomory, no. 135; D. Sutton, "Aspects of British Collecting, Part II, V, New Trends," *Apollo*, December, 1982, p. 363, fig. 12.

Exhibitions: *Art in Italy 1600-1750*, Detroit Institute of Arts, 1965, no. 34; Wildenstein, no. 12.

Mattia Preti
Italian, 1613-1699
SALOME WITH THE HEAD OF JOHN THE BAPTIST, c. 1648
oil on canvas, 47 1/4 x 67 3/8. SN 990

Mattia Preti, known as "Il Cavalier Calabrese" after he was knighted by Pope Urban VIII, was one of the great painters of the Italian baroque. He probably trained first under his brother, Gregorio, in his native Taverna. Around 1630 he went to Rome and is documented there at various times in the 1630s and most of the 1640s. He spent the later 1650s in Naples, then after a brief stay in Rome settled in Malta. Like many other artists of the Italian baroque, Preti traveled a great deal. During his frequent wanderings he assimilated a broad array of influences, which he fused in a powerful style of striking originality.

Salome with the Head of John the Baptist is a fully mature statement of the Caravaggism that marks much of Preti's work. The composition is close in spirit to Caravaggio's *The Incredulity of Thomas* (formerly Neues Palast, Potsdam) without being in any way dependent upon it. Above all Preti learned from Caravaggio how to capture the essence of a story with telling effect. Not merely content to repeat the picturesque sorts found in his concerts, Preti fully appreciated that Caravaggio's baroque style relied on classical restraint as much as on theatrical realism for its expressive impact. Thus, the artist dispenses with the supercharged drama found in most paintings of Salome, whose lurid story made her a favorite subject throughout the baroque. He asks us instead to contemplate the significance of the Baptist's martyrdom. The play of light and dark lends a greater presence to the nearly life-size figures, who are shown close up, so that the scene appears to be taking place before the viewer's very eyes. It further evokes a wonderfully hushed atmosphere that heightens the introspective mood conveyed by the solemn poses and intent expressions.

Salome is nevertheless typically eclectic in style. Besides Caravaggio himself, there are overtones of his closest follower, Orazio Gentileschi. The young girl holding the charger suggests, however, that these may have been derived from his daughter, Artemisia Gentileschi, a famous artist in her own right. The hunched figure and craggy face of Herod, shown wearing a turban and mantle with deep folds, are an idiosyncratic interpretation of singular types found in paintings by the Dutch Caravaggesque painter Dirck van Baburen. From Guercino comes the color scheme of Herod's orange-yellow robe, Salome's blue-and-gold dress, and the executioner's red shirt that enlivens the picture.

Preti's development is highly problematic, though a forthcoming article by Brian D'Argaville should help to clarify it. Based on the conventional wisdom that Caravaggism all but died out around 1630-1635, Roberto Longhi and most other scholars after him have dated Preti's musical genre scenes and other Caravaggesque paintings like the Ringling *Salome with the Head of John the Baptist* to those years. However, the artist's biographer Bernardo de Domenici states that Preti first adopted classicism before turning to Caravaggio's manner. The evidence suggests that this phase of his career occurred during the 1640s.

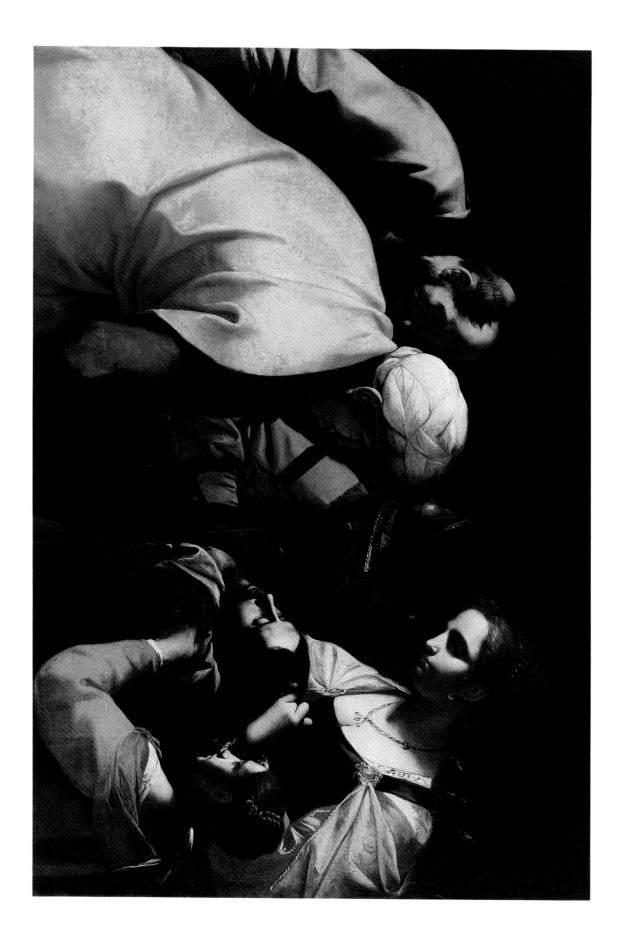

Preti was often absent from the Holy City in the 1630s. During those years he even seems to have paid a visit to the north, where he could have seen Baburen's work. Domenici says that Preti had a northern patron and met Rubens from whom, interestingly enough, he received a painting of *The Feast of Herod* that he later gave to Urban VIII, along with one by his own hand. There is nothing in the archives of the Barberini inventories, however, to identify the Ringling canvas with the latter. In any case, Preti spent almost all of the following decade in Rome. He presumably began working in a Caravaggesque style in the period 1641-1643. Most likely he learned it third-hand from pictures by Caravaggio's followers Bartolomeo Manfredi and the Frenchman Simon Vouet, as well as their disciples. To this he added elements absorbed from Guercino during his travels over the next two years. Such a combination of influences can be seen in a *Concert* (private collection, Naples) that was probably done shortly after his return to Rome in 1646. The Ringling picture is, like the coeval *Tribute Money* (Brera, Milan), a transitional work of two years or so later. A similar bearded old man can be found by the side of Christ in *The Raising of Lazarus*, while the regular features of Salome, seemingly derived from Vouet's classicizing Roman works of the late 1620's, recall those of Sofronia in the pendant *Clorinda Liberating Olinda and Sofronia* (both are in the Galleria di Palazzo Rosso, Genoa). This pair of paintings must have been done close to 1650, nearly ten years later than is presently thought, as they directly anticipate the definitive style Preti arrived at in Naples. The relatively late date of *Salome* indicates that Caravaggism in Rome, rather than suffering a sudden decline around 1630, managed to endure nearly as long as it did in Naples, where it persisted past mid-century.

Provenance: Matthiesen Fine Art Ltd., London, 1981, acquired 1985.

Salvator Rosa
Italian, 1615-1673
ALLEGORY OF STUDY, c. 1649
oil on canvas, 54 1/4 x 38 1/8. SN 152

Rosa was primarily a painter of romantic, often temptestuous landscapes that reflect the same pessimism as his allegorical scenes with philosophers, hermits, and saints. He also painted a number of portraits of himself, his family, and friends. The present work poses severe problems of interpretation, for it partakes of both allegory and portraiture. It comes closest to the personifica- tion of Study in Cesare Ripa's *Iconologia,* which Rosa often used as a source for his learned imagery: a young man who sits holding a book in his left hand and a pen in his right. Missing, however, is the scholar's oil lamp and the cock, symbol of vigilance and solicitude. Ripa's descrip- tion is accompanied by the legend, misattributed by him to Juvenal whose satires provided a model for Rosa's: "But your delight has been to grow pale over nightly study." As such, *Allegory of Study* is an apt expression of the artist's own erudite interests.

The Ringling canvas has often been linked to a picture called *La Menzogna (Deception;* Pitti Palace, Florence), with the suggestion that they represent ancient and modern poetry. Against this is the testimony of the artist's first biographer, Filippo Baldinucci, who states that the Pitti painting depicts "a philosopher showing a mask to another person." He adds that it was done for Giancarlo de' Medici and was accompanied by a picture of St. Anthony in the wilderness; significantly, no reference is made to our canvas. The two pictures are, however, nearly identical in size and form natural complements. As they were certainly done not long before Rosa left Florence for Rome in 1650, it is hard not to see them as pendants. *Allegory of Study* and *La Menzogna* may be taken as representing the self-denial and dissemblance of Epictetus and the Cynics, whose Stoicism formed the basis of Rosa's moral philosophy.

One instinctively feels as well that both are portraits. Indeed, *Allegory of Study* was once misread as a self-portrait, though the features clearly do not belong to Rosa. Nor does it represent the painter Jacques Courtois, as claimed in an inscription on the relining of another version showing only the head and shoulders that came to light in 1968 (Giancarlo Baroni, Florence). The head nevertheless has a strong sense of individuality, as does that of the philosopher in *La Menzogna.* Despite the element of idealization, they cannot be merely generalized types, like Rosa's saints. The key to their identities can perhaps be found in the Florentine circle of intellectuals surround- ing Giancarlo de' Medici, who commissioned *La Menzogna.* As Peter Tomory once proposed in an unpublished paper, the central figure in *La Menzogna* may yet turn out to be the court poet Antonio Abati, a renowned satirist with whom Rosa enjoyed a close friendship until professional jealousy led to their falling out in 1650. In any case, the person in *Allegory of Study* cannot be the philosopher Giovanni Battista Ricciardi, Rosa's best friend who, it has recently been demonstrated, is the subject of an allegorical portrait in the Metropolitan Museum that was long considered a self-portrait of the artist. Yet the character of our painting gives every indication that the sitter must have been equally well known to Rosa.

Provenance: Robert, Earl of Grosvenor, First Marquis of Westminster, London; Duke of Westminster; Christie, London, July 4, 1924, no. 38; Leyton Gallery, London, acquired John Ringling 1925.

Selected bibliography: Suida, no. 152; L. Salerno, *Salvator Rosa,* Milan, 1963, p. 120, pl. 28; B. Frederickson and F. Zeri, *Census of Pre-Nineteenth Century Italian Paintings in North American Public Collections,* Cambridge, Mass., 1972, p. 177; H. Langdon, "Salvator Rosa in Florence 1640-1649," *Apollo,* C, 1974, p. 192, pl. 8; Tomory, no. 165; L. Salerno, *L'opera completa di Salvator Rosa,* Milan, 1975, no. 103.

Exhibitions: *Masterpieces of World Art from American Museums,* National Museum of Western Art, Tokyo, 1976, no. 31; *Salvator Rosa in America,* Wellesley College Museum, 1979, no. 2; Wildenstein, no. 41.

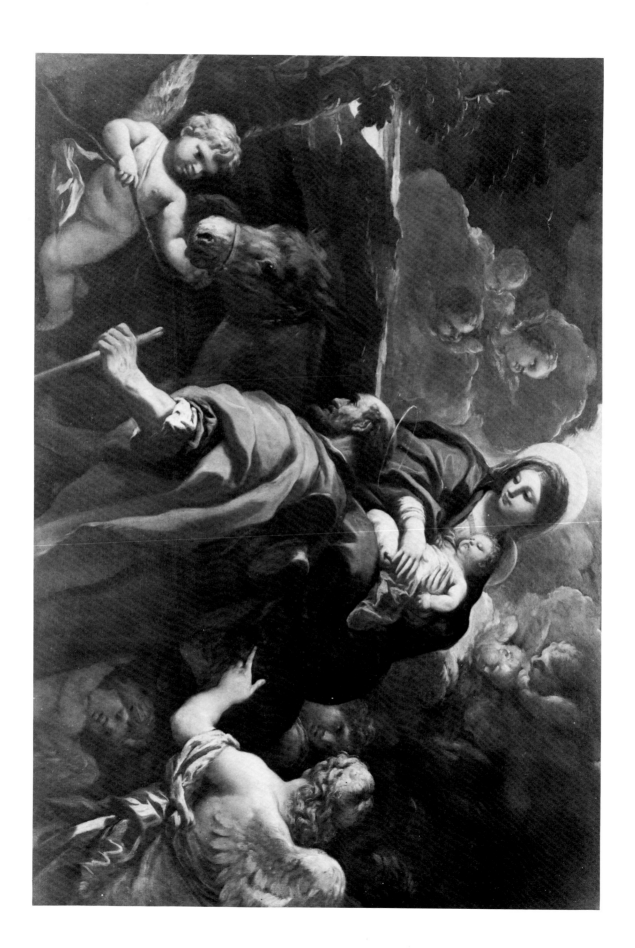

Luca Giordano
Italian, 1634-1705
THE FLIGHT INTO EGYPT, c. 1696
oil on canvas, 60 1/8 x 86 1/4. SN 157

Giordano succeeded the Spaniard Jusepe Ribera as the preeminent artist of Naples, then inherited the mantle of Pietro da Cortona as the leading painter of decorative cycles in Italy. In 1692 he was called to Spain, which ruled Naples. During his ten-year stay there, he was inevitably affected by Spanish art. *The Flight into Egypt* is, in fact, derived from a painting in the Museum of Fine Arts, Budapest, by Bartolomé Estaban Murillo, the most influential painter in Spain during the latter half of the century, who had died only a decade before Giordano's arrival. It was presumably done around the same time as Giordano's treatment of this subject for the cycle devoted to the life of Mary in the convent church at Guadalupe from 1696, which was inspired by yet another *Flight into Egypt* by Murillo (Palazzo Bianca, Genoa).

The Ringling *Flight into Egypt* is an unusually strong painting from this, the final period of Giordano's activity. To convey the effect of night, he adopted Murillo's brown tonality instead of the colorful palette he normally used. The vigorous brushwork and gathering clouds with angels lend an animation to the picture that serves to heighten the sense of urgency of the Holy Family's flight. The horizontal format and large scale of the painting place the viewer close to the scene, as if the entourage were passing directly in front of him. The truncated composition is rare for Giordano at this stage of his career, raising the question whether the painting has been cut significantly at the top and bottom. The degree of bowing along the edges, however, indicates that the canvas has suffered few, if any, losses.

Provenance: Duke of Rutland, Belvoir Castle; Christie, London, April 16, 1926, no. 16; Rothschild Gallery, London.

Bibliography: M. Milkovich, *Luca Giordano in America*, Brooks Memorial Art Gallery, Memphis, 1964, p. 40; O. Ferrari and G. Scavizzi, *Luca Giordano*, Naples, 1966, II, p. 208, fig. 426; B. Frederickson and F. Zeri, *Census of Pre-Nineteenth Century Italian Paintings in North American Public Collections*, Cambridge, Mass., 1972, p. 86; Tomory, no. 157.

Giovanni Paolo Panini
Italian, 1691-1765
HERMES APPEARS TO CALYPSO
CIRCE ENTERTAINS ODYSSEUS AT A BANQUET, c. 1718-1720
oil on canvas, 50 1/2 x 63 1/4. SN 171, 172

Panini is best known for the kaleidoscopic memoirs of Rome's antiquities that he painted after 1730. The paintings from the first five years of his career were cast, however, in the much simpler mold of Giovanni Ghisolfi. Over the next several years his compositions became increasingly independent and elaborate. The handsome Calypso and Circe canvases date from the end of this critical period. They were probably done around 1718-1720, while he was working on the decorations for the Villa Patrizi. For the next decade, Panini concentrated on highly theatrical religious and legendary subjects in vast classical architectural settings. Here he has chosen two scenes in which Hermes rescues Odysseus from the enchantress Circe, who turned his men into swine, and from the island of Ogygia, where he stayed for seven years with the nymph Calypso. This early stage in his career was still a period of experimentation for the young artist (he entered the Rome Academy in 1719), and the Ringling paintings show a level of inspiration not often found in his later works. Though the execution is occasionally uneven, they are notable for their fresh color and liquid brushwork, which are fully rococo in flavor.

SN 171 signed l.l.: JO Paolo Panini f. Romae.

Provenance: First Lord Bateman, Shobdon Court, Herefordshire; Newman Gallery, London, acquired John Ringling.

Bibliography: Suida, nos. 171-172; F. Arisi, *Gian Paolo Panini*, Piacenza, 1961, pp. 47-48, 55, 114-115; B. Frederickson and F. Zeri, *Census of Pre-Nineteenth Century Italian Paintings in North American Public Collections*, Cambridge, Mass., 1972, p. 157; Tomory, nos. 145-146.

Exhibitions: Royal Academy, 1887, SN 171 as no. 91, SN 172 as no. 211; Wildenstein, no. 36.

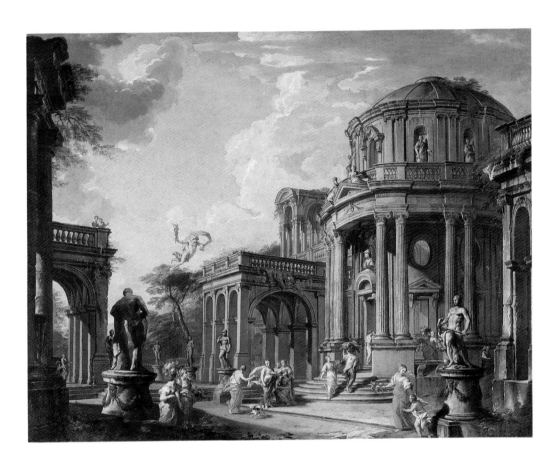

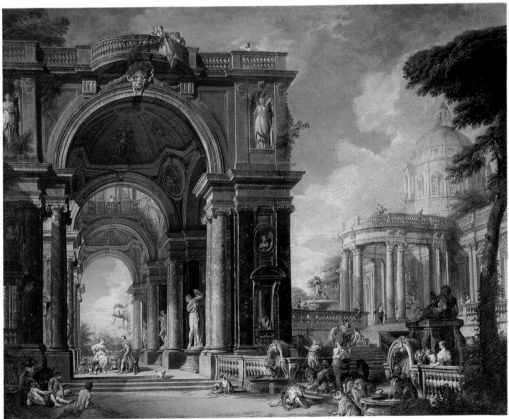

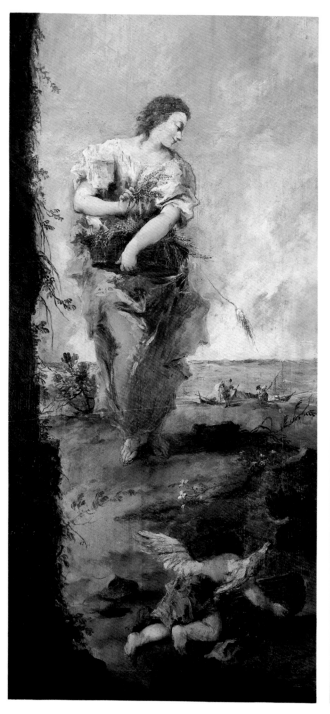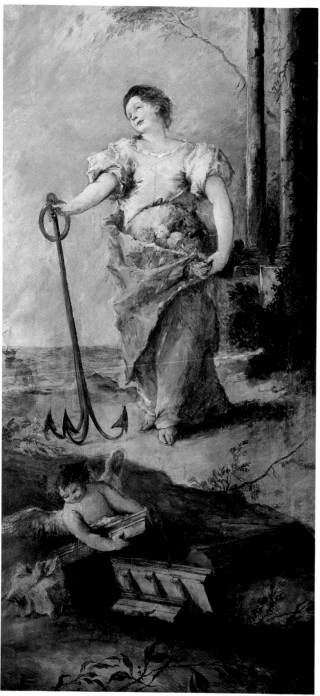

Francesco Guardi
Italian, 1712-1793
HOPE, ABUNDANCE, AND FORTITUDE, late 1740s-early 1750s
oil on panel, 63 1/2 x 30 3/4, 62 1/2 x 30 1/2. SN 189, 190

Francesco Guardi's reputation rests on his atmospheric views of Venice, but the first part of his career was spent in the studio of his older brother, Antonio, as a painter of religious and allegorical subjects. They often copied the work of other artists, and their style presents an amalgam of the three Giovannis who dominated Venetian art during the first half of the eighteenth century: Pellegrini, Piazzetta, and above all Tiepolo, who was Antonio's brother-in-law. Because they practiced the same manner and often collaborated on their more important commissions, it is difficult to distinguish their hands and chart their individual development. The Ringling panels have rightly been given to Francesco, though not without dissent. The figures are differentiated from Antonio's by their rustic character and correspondingly more solid but less elegant construction. They are derived from a type found in Tiepolo's pictures of the 1730s, as is the nervous brushwork, which threatens at times to dissolve forms almost entirely. The palette, however, owes more to Pellegrini.

The intended purpose and location have been disputed. The panels have been called organ shutters and cupboard doors commissioned by a church or religious confraternity. In the first place, however, it is likely that they originally formed one painting and were divided at a later time. Moreover, their meaning is purely secular. The women correspond in a general way to the personifications in Cesare Ripa's *Iconologia* of Abundance on the left, holding her characteristic sheaf of grain, and Hope on the right, whose attributes are flowers and an anchor, which "gives stability and security to the ship, as hope does to a man on the tempestuous sea of life." The broken columns and cornices are references to the Philistine temple destroyed by Samson, who was legendary for his prodigious strength, while the putti remind us that love assists fortitude.

The date has proved especially problematic. SN 189 previously bore the inscription "L'anno 1747," which came off so easily in light cleaning that it can only have been a later addition and was at best a reconstruction of a previous inscription. The pair can be placed as late as the 1760s on the basis of *The Miracle of St. Hyacinth* (1763, Kunsthistorisches Museum, Vienna) and *The Judgment of Paris* (A. Pereire, Geneva). It is true that Francesco did not radically alter his figure style over time (compare *SS. Peter and Paul Adoring the Trinity*, c. 1777, Parish Church, Roncegno). Our pictures are nevertheless cast so much in Antonio's mold both conceptually and stylistically that there is every reason to believe they were done before his death in 1760. In comparison with Francesco's landscapes, they should be assigned a date no later than the early 1750s; hence, the lost inscription may well have been correct.

SN 189 signed on column: F. Guardi f (L'anno 1747?).

Provenance: Eugene Glaenzer, New York, before 1922; Collis P. Huntington, New York; Anderson Galleries, New York, April 15, 1926, nos. 78-79; Julius Böhler, Munich, 1928.

Selected bibliography: D. von Hadeln, "Two Allegorical Figures by Francesco Guardi," *The Burlington Magazine*, 50, 1927, pp. 254-259; A. Morassi, "Francesco Guardi as a Figure Painter," *The Burlington Magazine*, 55, 1929, p. 299; M. Goering, *Francesco Guardi*, Vienna, 1944, pp. 23-24, 79; Suida, nos. 189-190; V. Moschini, *Francesco Guardi*, Milan, 1956, no. 21, pp. 12, 14, 18; R. Pallucchini, *La Pittura veneziana del settecento*, Venice, 1960, pp. 131, 135-136, 139; S. Sinding-Larsen, "Four Paintings by the Guardis in Oslo and the artistic ideals of Giovanni Antonio and Francesco Guardi," *Acta Institutione Romanum Norvegiae*, I, 1962, pp. 183-184; D. Mahon, "The Brothers at the Mostra dei Guardi: some impressions of a neophyte," *Problemi guardeschi arte del convegno . . . della mostra dei Guardi*, Venice, 1967, pp. 85-87, 98-99, 103-104, 109, 151-155, pls. 44-45; A. Morassi, *Guardi*, Venice, 1973, I, pp. 144-145, 348, II, pls. 229-231; L. Bortolatto, *L'opera completa di Francesco Guardi*, Milan, 1974, p. 109, nos. 334-335; Tomory, nos. 90-91.

Exhibitions: *The Guardi Family*, Museum of Fine Arts, Houston, 1958, nos. 3-4; *Guardi*, Palazzo Grassi, Venice, 1965, nos. 70-71.

Giovanni Battista Tiepolo
Italian, 1696-1770
Domenico Tiepolo
Italian, 1727-1804
ALLEGORY: GLORY AND MAGNANIMITY OF PRINCES, c. 1758
fresco transferred to canvas, 148 x 75. SN 652

The light-filled style created by Giovanni Battista Tiepolo was the epitome of the rococo. He also painted several series of grisailles imitating sculpture. All are allegories or mythologies appropriately classical in conception and style. The present fresco comes from an unidentified villa in Vicenza near his native Venice, where the artist was active in the late 1750s. The cycle also included two unrelated paintings of Mars and Venus (private collection, Turin) and a Bacchic head (private collection, Venice). Tiepolo relied heavily on assistants in such commissions. In this instance, the work is by his son, Domenico, who served as his chief assistant after Tiepolo returned from working on the decorations for the Residenz in Würzbug in 1750-1753, which remain his greatest achievement. It is very similar to Domenico's grisailles from the Palazzo Canossa, Verona. They can be assigned to him on the basis of the pastoral scenes in the Villa Valmarana, Vicenza, which are signed and dated 1757. Domenico was a gifted artist in his own right, as the high quality of this painting attests.

It is by no means the only large-scale grisaille designed by Tiepolo, but nothing quite prepares us for the fresco's grandiose treatment, which is fully in keeping with its allegory. Shown are Asia, whose attribute is the pyramid, and her conquerer, Alexander the Great. There is another level of meaning as well, inspired by Ripa's *Iconologia*. The woman with the pyramid and gold belt represents the Glory of Princes, while the cornucopia and lion are symbols of magnanimity. The precedents for such an illusionistic group of life-sized statues seen against a wall lies mainly in the history of sculpture instead of painting itself. In fact, the figure of Alexander suggests the inspiration of Michelangelo's statues of Lorenzo and Giuliano de' Medici in the Medici Chapel, Florence.

Provenance: Unknown villa, Vicenza; Barone Franchetti; Fratelli Simonetti; sold Tavazzi, Rome, April 25-May 6, 1932, no. 541; Adolph Loewi Gallery, New York, acquired 1951.

Bibliography: A. Morassi, *A Complete Catalogue of the Paintings of G. B. Tiepolo*, London, 1962, p. 48, fig. 372; V. Schmidt, "Zu Tiepolos Asien-Darstellung in Würzburg," *Zeitschrift für Kunstgeschichte*, 37, 1974, pp. 59-60; M. Santifaller, "Le Soprapporte dei Tiepolo nel Palazzo Canossa di Verona," *Arte Veneta*, 28, 1974, pp. 283-284, no. 21, fig. 369; idem, "Die Gruppe mit die Pyramid in Giambattista Tiepolos Treppenhausfresko der Residenz zu Würzburg," *Münchner Jahrbuch für Bildende Kunst*, 1975, p. 196, fig. 3; B. Frederickson and F. Zeri, *Census of Pre-Nineteenth Century Italian Paintings in North American Public Collections*, Cambridge, Mass., 1972, p. 197; Tomory, no. 109.

Exhibitions: *Il Settecento italiano*, Palazzo della Biennale, Venice, 1929, p. 68.

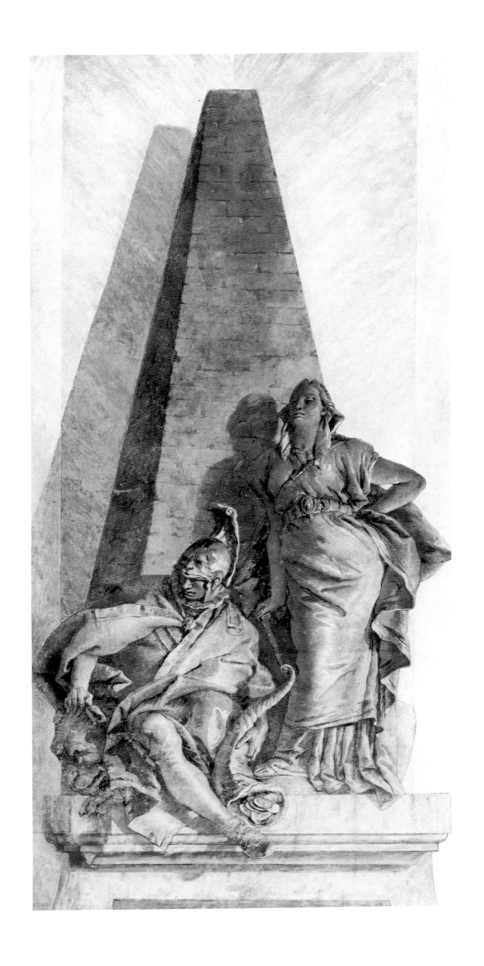

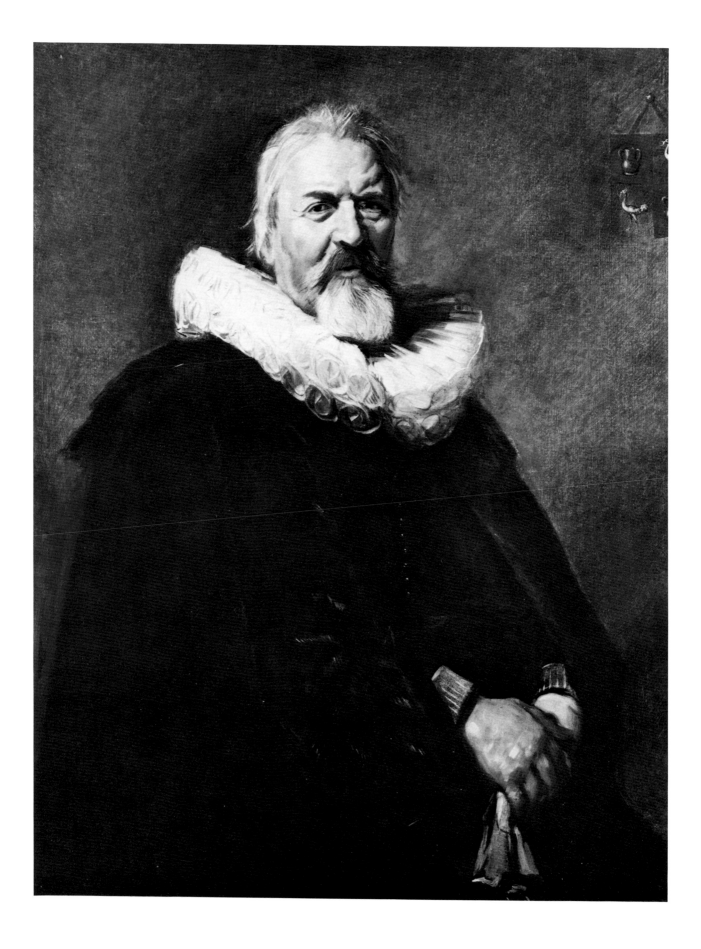

Frans Hals
Dutch, 1585-1666
PIETER JACOBSZ. OLYCAN, c. 1639
oil on canvas, 43 1/4 x 34. SN 251

Frans Hals of Haarlem was the first great portraitist of seventeenth-century Holland. Be they confident or contemplative, his sitters' poses, expressions and gestures convey the vitality of the era, when the Dutch republic rose to become a mighty commercial and naval power. Though cut down slightly, the Ringling canvas remains one of Hals's most imposing single portraits. Few paintings by him have such a powerful characterization.

As usual with Hals's work, the portrait is painted in a limited number of colors, but within this seemingly restricted range he produced almost infinite tonal nuances. It has been said that Hals's palette included a hundred different blacks. The face has the broad, rapid brushwork that the artist had previously reserved for his genre pictures. It invests Olycan with lifelike spontaneity, creating the illusion that the expression playing across his features has been captured in an instant, as if he were in the act of speaking directly to us. This sense of exchange with the viewer lies at the heart of baroque portraiture.

Pieter Jacobsz. Olycan (1572-1658) was one of Haarlem's leading citizens. A wealthy brewer, he served the city as mayor and was a member of the States General that governed Holland. In all, Hals painted nine known portraits of the Olycan family. Unlike most Dutch artists, he took great care to make his portraits of women a close match in personality and interest to those of the men he painted. Thus, Hals's portrait of the sitter's wife, Maritge Vooght Claesdr. (1639, Rijksmuseum, Amsterdam), is a worthy companion to the Ringling painting. Although lacking the forceful presence of Olycan himself, she is depicted as a pillar of quiet strength and wisdom.

Provenance: Geertruyd Olycan, wife of Jacob Benningh, Haarlem; Sutton Hall, May, 1922; A. Reyre, London, 1926.

Selected bibliography: W.R. Valentiner, "Rediscovered Paintings by Frans Hals," *Art in America*, XVI, 1928, pp. 235ff., 248ff.; idem, *Frans Hals Paintings in America*, Westport, 1936, p. 66; Suida, no. 251; S. Slive, *Frans Hals*, London, 1970-1974, I, pp. 123ff., II, pl. 206, II, pp. 68ff.; Wilson, no. 83.

Selected exhibitions: *Frans Hals*, Frans Hals Museum, Haarlem, 1962, no. 44; Wildenstein, no. 32.

Karel Dujardin
Dutch, 1622-1678
HAGAR AND ISHMAEL IN THE WILDERNESS, c. 1662
oil on canvas, 73 3/4 x 55. SN 270

Dujardin divided his career between Italy and Holland. A pupil of the Dutch Italianate landscape painter Nicolaes Berchem in Rome, he devoted most of his work to scenes of the Campagna with picturesque genre figures. While living in Amsterdam in the late 1650s, he also turned to history painting in a classical vein, then much in favor in Holland. *Hagar and Ishmael* is, with *St. Peter Healing the Sick* (Van Hattum Collection, Ellewoutsdijk) and *The Conversion of St. Paul* (National Gallery, London), one of the group of religious subjects that followed around 1662. Closely related in theme, size and treatment, they show the heathen being converted, the sick being healed, and the outcast being comforted. Together they represent one of the major achievements of their kind in Dutch seventeenth-century art. The combination of classicism and baroque drama shows a general debt to Ludovico Carracci of Bologna and his early school. Indeed, *Hagar and Ishmael* is treated very much like a supercharged Annunciation by Giovanni Lanfranco. This nevertheless remains a distinctly Dutch picture. Dujardin has affinities of style with his contemporary Caesar van Everdingen and of expression with the Utrecht Caravaggesque painter Hendrik Ter Bruggen. Only a Northerner would have had the charming idea of including the young angel who helps Ishmael.

The theme of Hagar and Ishmael was popular in Dutch seventeenth-century art. Protestant Holland was a haven for outcasts like the Jews. Ironically, its religious tolerance did not extend equally to Catholics, who constituted a sizable minority. Though forbidden to have their own churches, they were quietly allowed to worship at home in private chapels. Dujardin, a Catholic, must have executed *Hagar and Ishmael in the Wilderness* for just such a chapel, as paintings were banned from the interiors of Dutch Calvinist churches.

Signed l.l.: "K DU JARDIN fe"

Provenance: sold John van Spangen, London, February 10, 1748, to Clark; Catharina van Hunthum sale, Amsterdam, April 22, 1762, no. 2 to Wenix for Locquet; Peter Locquet sale, Amsterdam, September 22, 1783, no. 165, to Yver; De Vouge sale, Paris, 1784; John Ringling.

Bibliography: J. Smith *A Catalogue Raisonné of the Works of the Most Eminent Dutch, Flemish and French Painters*, London, 1834, V, p. 246, no. 39; C. Blanc, *Ecole hollandaise*, Paris, 1867, II, p. 89; C. Hofstede de Groot, *Holländischen Malern des XVII Jahrhunderts*, Esslingen, 1926, IX, no. 3; Suida, no. 270; H. Gerson, *Dutch Painting*, Amsterdam, 1951, II, p. 22, pl. 52; F. Simpson, "Dutch Paintings in England Before 1760," *The Burlington Magazine*, 95, 1953, pp. 40-41; E. Brochhagen, *Karel Dujardin*, Cologne, 1958, p. 79ff; P. Rosenberg, "Le Musée de Sarasota en Floride," *L'Oeil*, no. 138, June, 1966, pp. 4-11, color pl. 6; Wilson, no. 69.

Exhibition: *Gods, Saints & Heroes, Dutch Painting in the Age of Rembrandt*, Detroit Institute of Arts, 1980, no. 64.

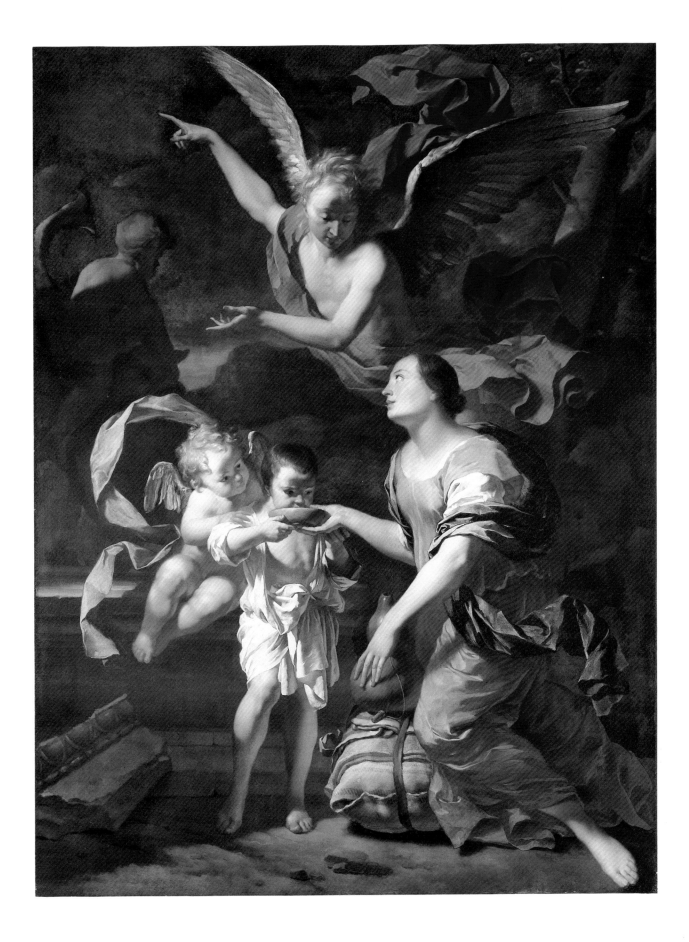

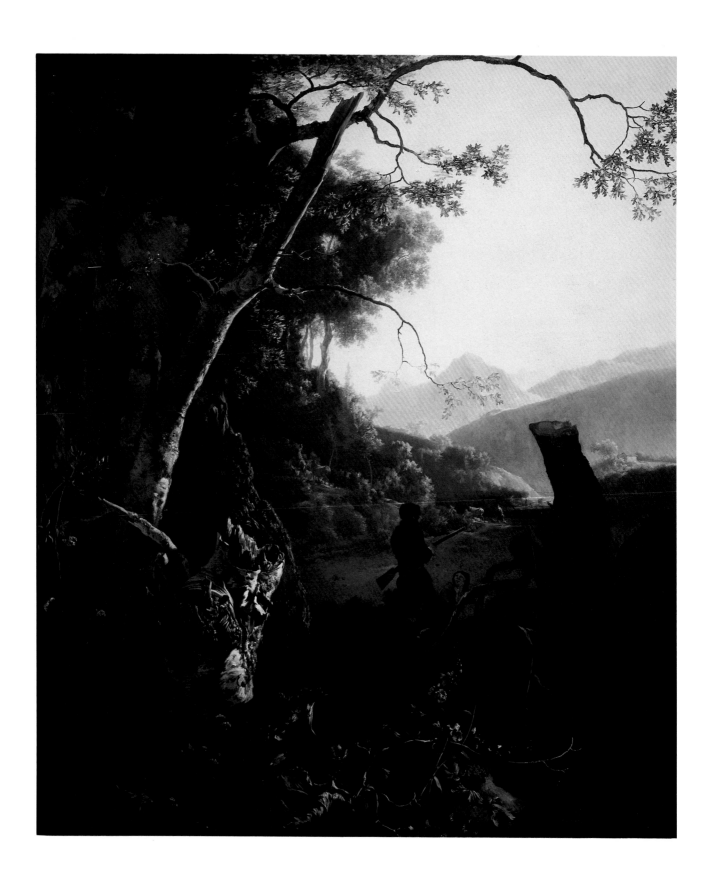

Adam Pynacker
Dutch, 1622-1673
LANDSCAPE WITH HUNTERS, c. 1665
oil on canvas, 32 1/4 x 27 3/4. SN 896

The seventeenth century was the great age of landscape painting in Holland. At the same time that Jan van Goyen and Salomon van Ruysdael were depicting the dunes, rivers and polders around them, other Dutch artists, attracted by the lure of the south, flocked to Rome, where they painted views of the Campagna. The two traditions remained separate until the 1640s, when the Dutch Italianates began returning to their native country. Among them was Adam Pynacker, who had spent three years in Rome. His early works are serene landscapes painted in the luminescent colors of Jan Asselijn. *Landscape with Hunters* belongs to Pynacker's second period, which probably began when he moved to Amsterdam around 1659. The composition is derived from Jan Both's scenes of the Roman Campagna. Pynacker's nature, however, is wilder and more agitated. A romantic note is struck by the gnarled growth in the foreground, which was inspired by the landscapes of Jacob van Ruisdael. It is heightened to almost surrealist intensity through the sharply contrasting light, which is found in other Dutch Italianate paintings of the same decade as well. The pessimistic mood is relieved by the sun-filled vista in the distance, which shows Pynacker's wondrous mastery of light.

Signed l.r.: A Pynacker

Provenance: possibly Sir John Murray, London, sold June 19, 1852; possibly A. F. Walter, London, sold June 29, 1913; private collection, Sweden; J. H. Galloway, Ayr, Scotland, 1925; Leonard Koetser Ltd., London; H. Schickman Gallery, New York, acquired 1971.

Bibliography: possibly C. Hofstede de Groot, *Holländischen Maler des XVII Jahrhunderts*, Esslingen, 1926, IX, no. 14; Wilson, no. 113.

Exhibitions: Wildenstein, no. 40.

Jan Steen
Dutch, 1626-1679
RAPE OF THE SABINE WOMEN, c. 1665-1667
oil on canvas, 27 1/2 x 36 1/2. SN 269

Jan Steen was the clown prince of Dutch art. His genre scenes expose human folly with endless good humor, keen insight, and surprising sympathy. A Catholic, he was also a serious religious painter and occasionally turned to historical subjects as well, which he often treated with the same wit as his tavern scenes. *The Rape of the Sabine Women*, his earliest classical painting, is a mirthful parody that reduces the epic conflict seen in Nicholas Poussin's famous picture (Metropolitan Museum, New York) to a peasant revel at a kermesse that has gotten out of hand. The poses have all been taken from prints after works by classical and baroque artists, but they have acquired a gleeful irreverence in Steen's translation. The symbolism adds to the ribaldry. The girl reaching for the ribbon in the foreground stands for lost chastity, as do the rose and pearls. The bonds of marital fidelity, symbolized by the ivy, have likewise been loosened. The composition carries the ebullient action across the picture plane and into the beautifully painted landscape.

Provenance: H.A. Bauer sale, Amsterdam, September 11, 1820, no. 122; W. Gruyter, Amsterdam, 1833-1882; W. Gruyter sale, Amsterdam, October 24, 1882, no. 107; F.H. Wente sale, Paris, February 22, 1893; Schönlank, Cologne, April 28, 1897, no. 172; F. Kleinberger, Paris; W. Dahl, Düsseldorf; A. Preyer, Vienna, 1901; W.A. Clark, New York; American Art Association sale, New York, 1928.

Selected bibliography: J. Smith, *Catalogue Raisonné of the Most Eminent Dutch and Flemish Painters*, 1833, IV, no. 197; C. Hofstede de Groot, *Holländischen Maler des XVII Jahrhunderts*, Esslingen, 1907, I, no. 76; A. Bredius, *Jan Steen*, Amsterdam, 1927, p. 40, pl. 15; B. D. Kirschenbaum, *The Religious and Historical Paintings of Jan Steen*, New York, 1977, pp. 44-45, 68, 142, fig. 50; Wilson, no. 120.

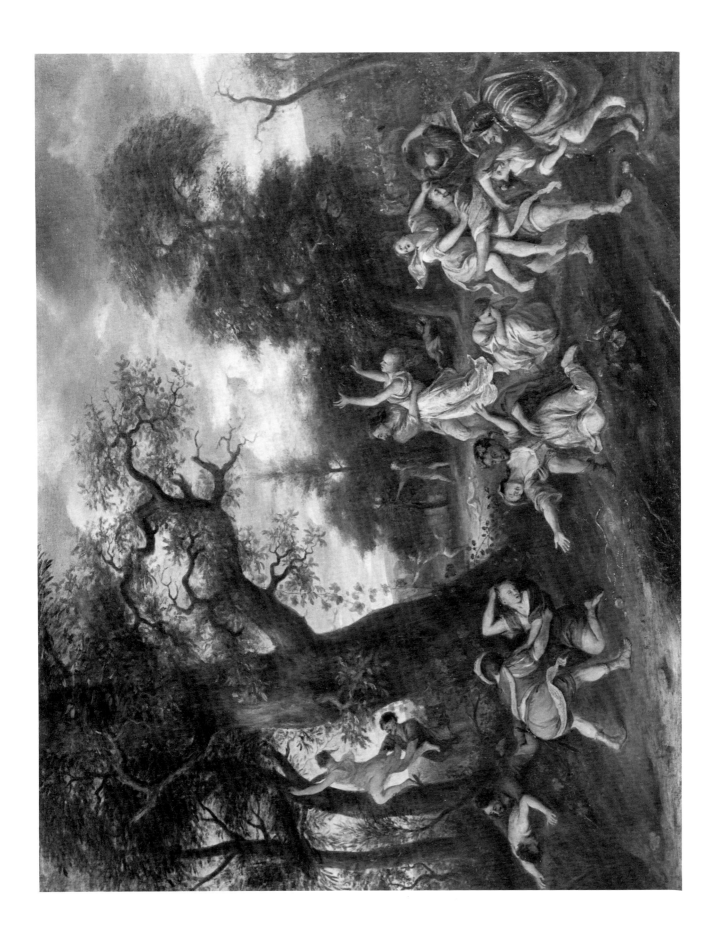

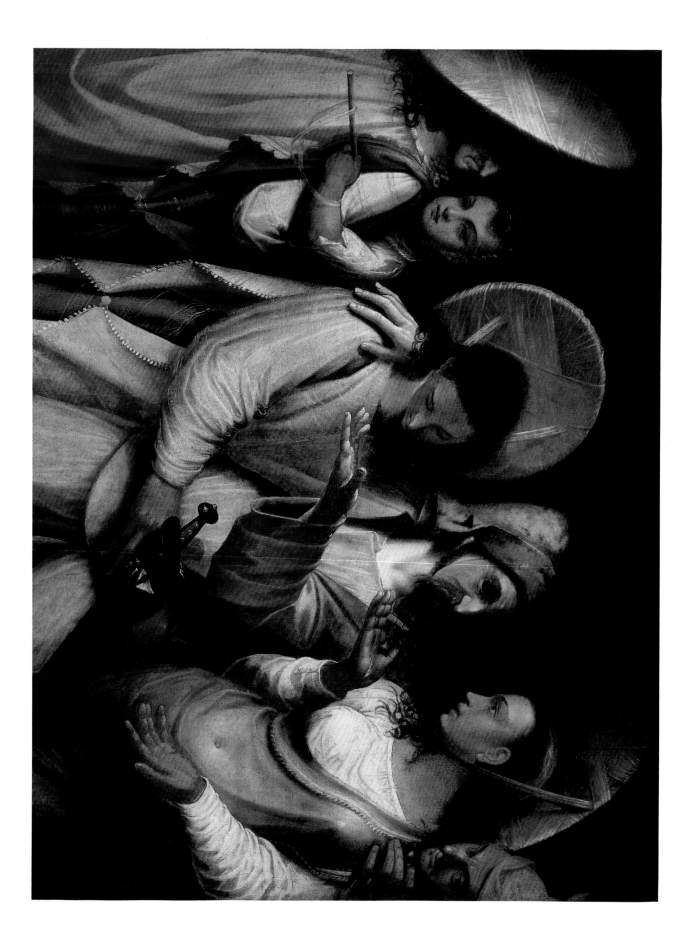

Franco-Flemish Artist
SCENE FROM THE COMMEDIA DELL'ARTE, c. 1595-1605
oil on canvas, 46 1/2 x 58 1/8. SN 688

The subject of this intriguing painting is a stock scene from the Italian commedia dell'arte. Pantaloon (or perhaps a Zany) is having his purse picked by a gypsy fortune teller who pretends to read his palm, while another plays with his false beard. They are identified as prostitutes by the presence to the left of an old procuress carrying a child. The women wear a distinctive hat, called a bern, which is well known from books and engravings of c. 1565-1590 when gypsy subjects were popularized throughout Europe.

The canvas belongs to a well-defined group of late sixteenth-century French scenes from the Italian commedia dell'arte. This tradition in turn had an impact on Italian painting and contributed to Caravaggio's two versions of *The Fortune Teller* (Louvre, Paris; Capitoline Museum, Rome). There is an apparent debt to the School of Fontainebleau in the figure on the right, which was derived from a famous composition of *The Finding of Moses* by Nicolo dell'Abate, known from a drawing in the Louvre. It is nevertheless executed in the naturalistic style current in Flanders during the 1560s and 1570s, though the intense color and monumental figures suggest a date as late as 1600-1605. The picture has given rise to considerable speculation about its authorship and date. Because it overlaps several schools, it has been attributed to various French, Flemish, and even Italian artists, including Jacques Bellange, Frans Floris the Younger, and Giovanni Battista Paggi.

The specific confluence, however, indicates a Fleming in the circle of Hieronymus Francken, who settled in Paris in 1566, or, more likely, Ambroise Dubois (Ambrosius Bosschaert), who came to Fontainebleau from Antwerp in 1573. He may yet turn out to have been a member of the second generation of artists who arrived from Flanders around 1595 — and who may have been responsible for the bulk of commedia dell'arte subjects in France, such as *Woman Choosing between Youth and Age* (Earl of Elgin, Broomhall, Fife). Unfortunately, it is impossible to connect our painting with any of the two dozen or so Flemish artists known to have been active there during the latter half of the century, as few signed or documented works survive. A much smaller, and undoubtedly later, copy was sold at Christie's, London, February 14, 1974, no. 98.

Provenance: John Conyers, c. 1765, and his heirs, Copped Hall, Essex, until 1869; E.J. Wythes, Copped Hall, Essex, and his heirs until 1946; Christie, London, March 1, 1946, no. 12; Frank Sabin, London; Durlacher Brothers Gallery, New York, acquired 1955.

Bibliography: S. Béguin, *L'Ecole de Fontainebleau*, Paris, 1960, p. 109, ill. p. 104; A. Chatelet and J. Thuillier, *La Peinture française*, I, *de Fouquet à Poussin*, Geneva, 1963, p. 112; W. Smith, *The Commedia dell'Arte*, New York, 1964, ill. p. 294; A. Blunt, "Georges de la Tour at the Orangerie," *The Burlington Magazine*, August, 1972, p. 519, fig. 6; D. Sutton, "Fontainebleau: A Sophisticated School," *Apollo*, January, 1973, XCVIII, p. 118, fig. 4; J.-P. Cuzin, *"La Diseuse de bonne aventure" de Caravage*, Louvre, Paris, 1977, pp. 22-23; *France in the Golden Age*, Metropolitan Museum, New York, 1982, p. 345; J.-L. Lévêque, *L'Ecole de Fontainebleau*, Neuchâtel, 1984, p. 141, ill. p. 139; *The Age of Caravaggio*, Metropolitan Museum, New York, 1985, p. 215.

Exhibitions: *Fontainebleau e La Maniera Italiana*, Naples, 1952, no. 50, pl. 48; *The School of Fontainebleau*, Fort Worth Art Center, 1965, pp. 30, 32, ill. p. 71; *L'Ecole de Fontainebleau*, Grand Palais, Paris, 1972, no. 249; Wildenstein, no. 2.

Nicolas Régnier
Flemish-Italian, 1591-1667
ST. MATTHEW AND THE ANGEL, c. 1625
oil on canvas, 42 1/2 x 48 7/8. SN 109

Régnier was born in Maubeuge in Flanders near the French border and studied in Antwerp under the Caravaggesque painter Abraham Janssens. Around 1615 he moved to Rome, then settled in 1626 in Venice, where he spent the remainder of his career. In the Holy City Régnier became a pupil of Bartolomeo Manfredi, the most influential follower of Caravaggio, and was closely associated with the French circle of Simon Vouet. This diverse background is reflected in *St. Matthew and the Angel.* The painting incorporates northern types into the Manfredi manner with a Gallic rhythm. It has, not surprisingly, been attributed to Manfredi himself, Vouet's follower Gerard Douffet, and varous Flemings and Dutchmen. The solution to its authorship was provided by a set of copies (collection unknown) of four evangelists, including the Ringling St. Matthew and a St. Luke after a signed work by Régnier in the Rouen Museum of Fine Arts. The series can be dated toward the end of the artist's Roman period, after which he abandoned Caravaggism. The copy indicates that the painting has been cut by some 30 percent at the bottom.

Régnier was inspired equally by Caravaggio's first painting of *St. Matthew and the Angel* (formerly Kaiser Friedrich Museum, Berlin) and by Vouet's *St. Jerome and the Angel* (National Gallery, Washington). Caravaggio shows the angel peering curiously at the text that the evangelist seated next to him is writing. Vouet's St. Luke, on the other hand, turns for inspiration to his heavenly companion as he translates the Bible into the Vulgate. Régnier adopts a similar composition but invests it with a touching intimacy. He depicts the angel guiding Matthew's pen across the page, almost as if the saint were a scribe taking dictation from the divine messenger.

Selected bibliography: Suida, no. 109; P. Rosenberg, "Le Musée de Sarasota en Floride," *L'Oeil,* 138, June, 1966, p. 6, fig. 3; B. Frederickson and F. Zeri, *Census of Pre-Nineteenth Century Italian Paintings in North American Public Collections,* Cambridge, Mass., 1972, p. 45; J. Held, "Caravaggio and His Followers," *Art in America,* May-June, 1972, p. 45, ill. p. 47; Tomory, p. 196; B. Nicolson, *The International Caravaggesque Movement: Lists of Pictures by Caravaggio and His Followers Throughout Europe from 1590 to 1650,* London, 1979, p. 40; P. Rosenberg, "France in the Golden Age: A Postscript," *Metropolitan Museum Journal,* 17, 1984, p. 39, fig. 20.

Exhibitions: *Figures at a Table,* Ringling Museum of Art, Sarasota, 1960, no. 6; *Caravaggio and His Followers,* Cleveland Museum of Art, 1971, no. 80; *France in the Golden Age,* Metropolitan Museum, New York, 1982, no. 123.

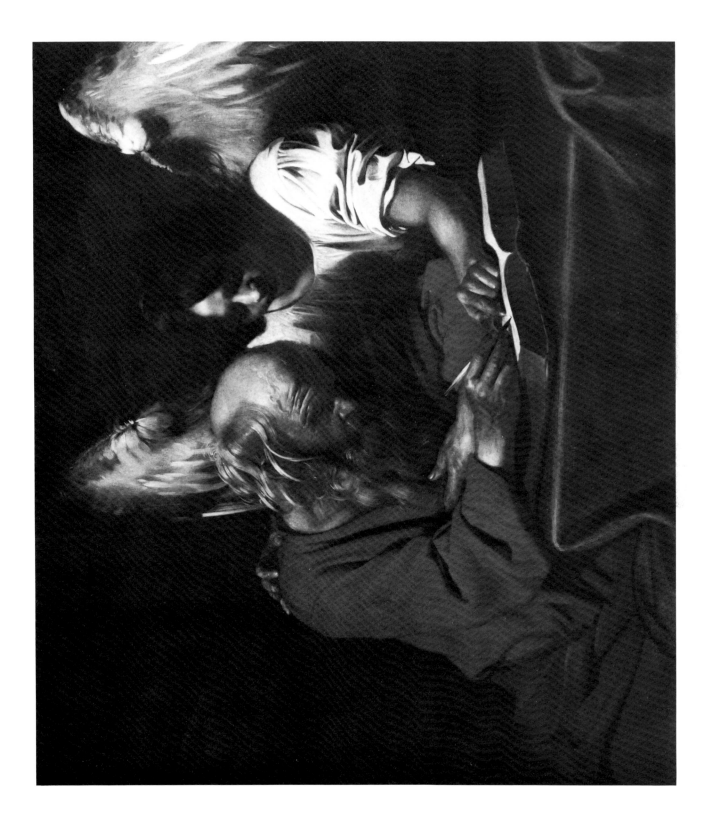

Simon Vouet
French, 1590-1649
MARS AND VENUS, c. 1640
oil on canvas, 57 1/2 x 42 1/2. SN 360

Simon Vouet, Nicolas Poussin, and the landscapist Claude Lorrain, were the foremost French painters of the seventeenth century. Like Poussin and Claude, Vouet went to Rome, where he became the leader of the French followers of Caravaggio during the 1620s. But whereas the other two settled there, returning to France only briefly, Vouet went back to his native land. There he gained almost immediate recognition and was eventually named First Painter to the King.

The subject of Mars and Venus enjoying their illicit affair, taken from Ovid's *Metamorphoses*, was popular throughout the seventeenth century and beyond. Vouet also drew on *Love Subdued* in Cesare Ripa's *Iconologia*, which quotes the Cynic philosopher Crates: "Insatiable desire subdues love, but if not, time will certainly, and if that is not enough, the snare will." The god and goddess are shown in the presence of Chronos, who is casting his net over Cupid, alluding to Vulcan's later capture of the unlucky pair. Thus, the moral of the picture is the victory of time (and, by extension, death) over love and, with it, beauty. The symbolism, however, is clearly secondary to the wonderfully human depiction of the amorous play between the two divinities. Venus has a delightfully seductive expression as she caresses the surly but enchanted Mars. Cupid, in turn, behaves exactly like a mortal child caught at some mischief by his reproachful father. The painting owes much of its charm to its masterful execution and expressive palette.

Nothing could be further removed from Poussin's rigorous art. Ironically, *Mars and Venus* was painted around 1640, at the beginning of Poussin's ill-fated stay in Paris at the invitation of Louis XIII. He was to leave a few years later, bitterly disappointed by his lack of success at the court, whose taste and politics Vouet understood fully. In a sense, their rivalry was to continue long after their deaths. Vouet's colorful decorative style provided the foundation for the painterly tradition that vied with Poussinesque classicism in France from the rococo through the romantic eras.

Selected bibliography: Suida, no. 360; A Pigler, *Barockthemen*, Budapest, 1956, II, p. 158; R. L. Manning, "Some Important Paintings by Simon Vouet in America," *Studies in the History of Art Dedicated to William E. Suida on His Eightieth Birthday*, London, 1959, pp. 297, 303, fig. 15; W. Crelly, *The Paintings of Simon Vouet*, New Haven, 1962, no. 139; Y. Picart, *Simon Vouet premier peintre de Louis XIII*, Paris, n.d., pp. 40, 60, no. 119; P. Tomory, "Simon Vouet's 'Venus, Mars, Cupid and Chronos,' " *Ringling Museum Newsletter*, December 1971.

Exhibitions: *French Paintings of the Time of Louis XIIIth and Louis XIV'th*, Wildenstein, New York, 1946, no. 54; *The Age of Louis XIII*, Cummer Gallery of Art, Jacksonville, 1969, no. 49; *Simon Vouet, First Painter to the King*, University of Maryland Art Gallery, College Park, 1971, no. 20; Wildenstein, no. 52; *France in the Golden Age*, Metropolitan Museum, New York, 1982, no. 121.

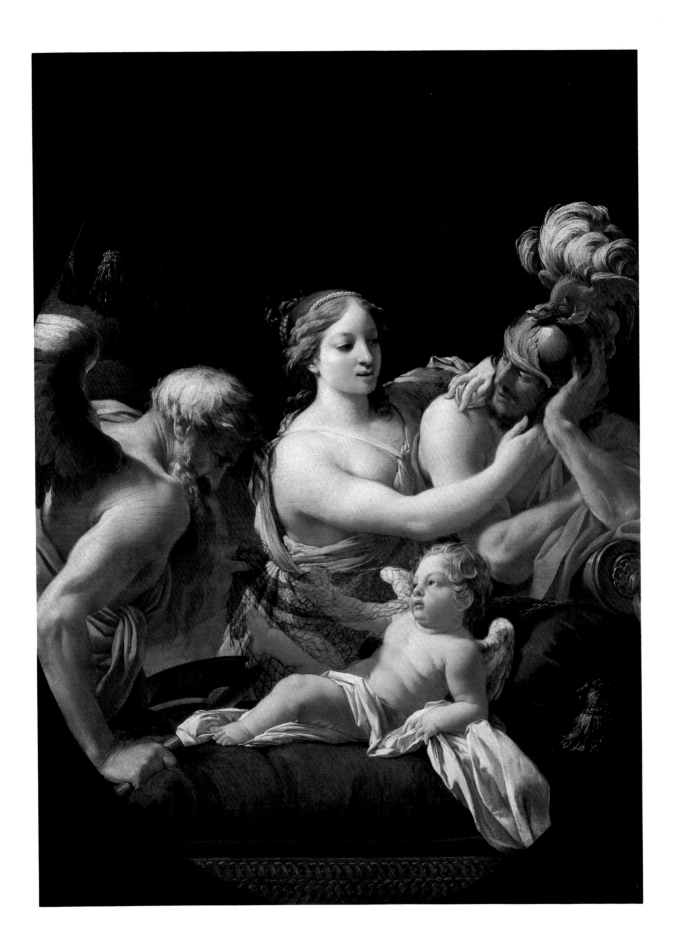

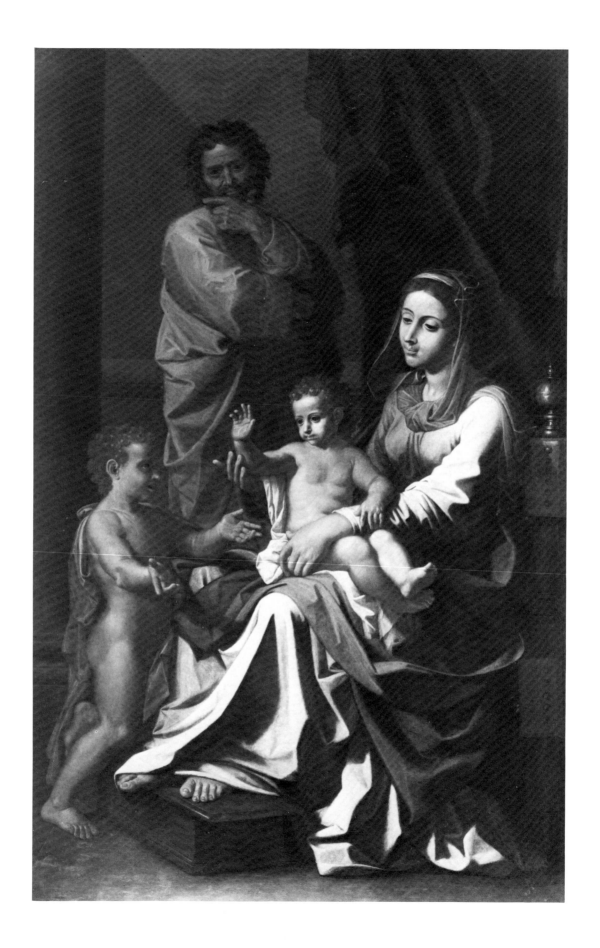

Nicolas Poussin

French, 1594-1665

THE HOLY FAMILY WITH THE INFANT SAINT JOHN, 1655

oil on canvas, 76 x 50 1/2. SN 361

Except for a brief stay in Paris in the early 1640s, Poussin spent his career in Rome. During his early years he adopted a lyrical Titianesque style, but by 1630 he had become the leader of the classical reaction in Italy against what he regarded as the excesses of the baroque. He was patronized mainly by the French, with whom his stoic outlook was in accord, and the Ringling *Holy Family* was probably painted for the Duc de Créqui, the French ambassador to Italy. It is one of the great achievements of Poussin's *maniera magnifica* (magnificent style), which lasted from about 1655 until his death ten years later. The painting's lofty conception makes great demands of the viewer. Of all the artist's Holy Families, it is the most grandiose and severe in conception. In the closely related *Holy Family with Elizabeth and St. John* (Hermitage, Leningrad) of about the same time, Poussin shows the figures in a clearly articulated, evenly lighted landscape. Here, however, he places them in a dark architectural setting, which removes the scene to an ideal realm. The central group is derived from an earlier *Madonna and Child with St. John* by him, now known only through Jean Pesne's engraving. In none of his other versions, however, are the figures treated so sculpturally. The Ringling painting achieves a calm monumentality that is timeless. Every aspect has been thought out with such rigor that not a single element could be changed without upsetting the internal logic of the composition.

Poussin was an enemy of superstition and mystical excess, but *The Holy Family with the Infant St. John* is hardly an arid exposition of his rational Catholicism. The *maniera magnifica* is characterized by a remarkable fusion of content and expressiveness, which makes his late religious paintings, like his mythological landscapes, vehicles of Poussin's most profound thoughts. The canvas is as contemplative as a Byzantine icon, and no less spiritual. The physical perfection of the figures and their measured dignity convey both a religious and a human ideal in the most lucid, concentrated terms, without resort to sentimental appeal. Poussin instead emphasizes the tender expression of the Virgin and the gentle interplay between the blessing Christ and St. John, who recognizes Him as the Saviour. He dispenses with the cross and hair shirt of Saint John traditional to this apocryphal event, which comes from Eastern texts about his life. Joseph assumes a new importance as well. His columnar form and reflective pose evoke an ancient philosopher. In his features is mirrored Poussin's own sense of wonderment and mystery, which is central to the painting's meaning.

Provenance: Duc de Créqui; Madame de Montmort (returned to artist); Sir Richard Worsley, London; Earl of Yarborough, London; Yarborough sale, Christie, London, July 12, 1929, lot 70, bought by Mr. Newton; Julius Böhler Gallery, Munich.

Selected bibliography: J. Smith, *Catalogue Raisonné of the Works of the Most Eminent Dutch, Flemish and French Painters,* London, 1837, VIII, p. 37, no. 70; C. Jouanny ed., *Correspondance de Nicolas Poussin,* Paris, 1911, pp. 436-439, 441; O. Grautoff, *Nicolas Poussin, sein Werk and Leben,* Munich, 1914, p. 256; W. Friedländer, *Nicolas Poussin, Die Entwicklung Seiner Kunst,* Munich, 1914, p. 122, ill. p. 242; T. Bertin-Mourot, "Addenda au catalogue de Grautoff depuis 1914," *Bulletin de la Société Poussin,* II, 1948, p. 48, pl. XII; D. Mahon, *Poussiniana, Afterthoughts Arising from the Exhibition,* Gazette des Beaux-Arts, 1962, p. 120; W. Friedländer, *Nicolas Poussin, A New Approach,* New York, 1964, pp. 68, 186, fig. 62; A. Blunt, *The Paintings of Nicolas Poussin, A Critical Catalogue,* London, 1966, no. 51, p. 218; idem, *Nicolas Poussin,* Washington, D.C., 1967, pp. 215, 301-302; J. Thuillier, *Tout l'oeuvre peint de Poussin,* Paris, 1974, no. 196; D. Wild, *Nicolas Poussin,* Zurich, 1980, I, pp. 150, 212, 214, II, p. 169, no. 83.

Selected exhibitions: *Nicolas Poussin, Peter Paul Rubens,* Cincinnati Art Museum, 1948, no. 19; *Nicolas Poussin,* Louvre, Paris, 1960, no. 107; *Poussin,* Villa Medici, Rome, 1977, no. 40; *Nicolas Poussin,* Staatliche Kunsthalle, Düsseldorf, 1978, no. 42.

Thomas Gainsborough
English, 1727-1788
PORTRAIT OF GENERAL PHILIP HONYWOOD, c. 1764
oil on canvas, 124 1/2 x 115 1/2. SN 390

This is by far Gainsborough's largest painting. It is also his first equestrian portrait and the only one in which the rider is actually mounted. His others follow the standard Van Dyckian formula observed in Joshua Reynolds's slightly later *Marquis of Granby* in the Ringling Museum, which depicts the military hero standing calmly next to his horse with a battle in the distance. Interestingly enough, both sitters participated as regimental colonels in the War of the Austrian Succession (1740-1748) and were promoted to general in the concurrent war against The Pretender Prince Edward. Honywood (who was at 6'3" a giant of a man for his time) retired in 1746 after suffering twenty-eight wounds! The Marquis, on the other hand, served during the Seven Years' War (1756-1763) and was elevated to Commander-in-Chief in 1766, the year Reynolds painted his portrait.

The mature style so richly in evidence in this canvas was the result of Gainsborough's exposure to major collections in Bath and its environs, which transformed his art. It was above all from Van Dyck's example that he learned how to paint elegant portraits of the greatest refinement and sophistication. For Honywood's portrait, Gainsborough relied on Van Dyck's *Charles I on Horseback* (mid-1630s, National Gallery, London), which was inspired by Titian's *Emperor Charles V* (1548, Prado, Madrid). An accomplished landscape painter, Gainsborough even replicated the wooded setting, which evokes a tranquil mood through the play of light. Honywood's stature is enhanced through association with the earlier painting. But whereas Van Dyck shows the king as a conquering emperor and chivalrous knight firmly in charge of the affairs of state, this is a purely ceremonial portrait.

Honywood has a glint in his eye, as if he is still ready to lead the charge. Were it not for his military garb, however, he would appear more the country gentleman enjoying a ride on his estate, Marks Hall, as he no doubt often did. The genial portrayal suggests that sitter and artist alike saw him in such terms. Gainsborough was patronized by the local gentry of Bath, where he moved from Suffolk in the autumn of 1759. A highly likable man, he enjoyed their company and shared their pleasures, above all music and riding. In fact, as we know from his letter to James Unwin, he drew a study of the splendid horse for Honywood's portrait while staying with Lord Pembroke over the spring or, more likely, the summer of 1764. Though the sheet is lost, this is among the few known instances where Gainsborough made a drawing directly for a painting.

Provenance: The Honywood Family, Marks Hall, Essex; Agnew's, London, 1898; Sir Edgar Vincent, 1908; Duveen, London, 1926, acquired John Ringling 1927.

Bibliography: C.R. Leslie and T. Taylor, *Life and Times of Sir Joshua Reynolds*, London, 1865, I, p. 249; Mrs. A. Bell, *Thomas Gainsborough*, London, 1897, p. 62; W.G. Boulton, *Thomas Gainsborough, His Life, Work, Friends and Sitters*, London, 1907, pp. 89-90; Sir W. Armstrong, *Gainsborough and His Place in English Art*, London, 1899 and 1909, pp. 115-116; M.H. Spielman, *British Portrait Painting*, London, 1910, I, p. 80; W.T. Whitley, *Thomas Gainsborough*, London, 1915, ill. p. 44; Suida, no. 390; M. Woodall, *Thomas Gainsborough*, London, 1949, pp. 56-57; E. Waterhouse, *Gainsborough*, London, 1958, p. 74, pl. 83; M. Woodall, *The Letters of Thomas Gainsborough*, 2d rev. ed., London, 1963, p. 155, no. 86 (to James Unwin); J. Hayes, *Gainsborough: Paintings and Drawings*, London, 1970, p. 18.

Exhibitions: Society of Artists, London, 1765; Paris, 1900, no. 70; Guildhall, London, 1902, no. 46; The Royal Academy, London, 1907, no. 79; *Old English Masters*, The Royal Academy, Berlin, 1908, no. 23; Copenhagen, 1908, no. 3; *Japan-British Exhibition*, Earl's Court, London, 1910, no. 18.

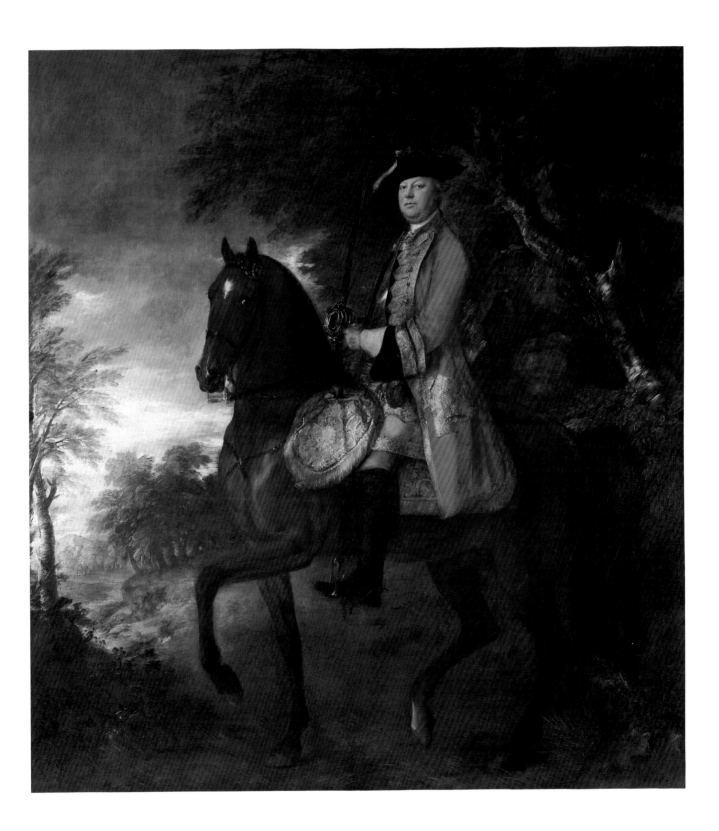

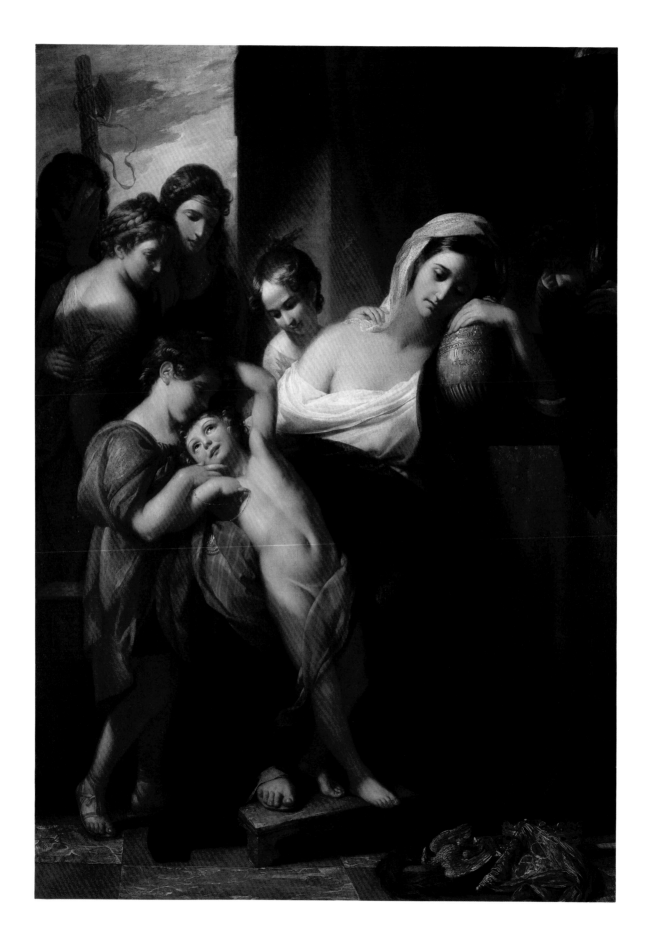

Benjamin West
Anglo-American, 1738-1820
AGRIPPINA AND HER CHILDREN MOURNING
OVER THE ASHES OF GERMANICUS, 1773
oil on canvas, 80 x 56 1/2. SN 403

After a brief career as a portrait painter in Philadelphia and New York, Benjamin West went to Italy in 1760 seeking further training. Under the influence of the Englishman Gavin Hamilton and the German Anton Mengs, he adopted the neo-classicism espoused by Johann Winckelmann. Upon settling in London, West enjoyed phenomenal success: he was appointed history painter to King George III and helped to found the Royal Academy, which he later served as president for twenty-eight years.

Agrippina and Her Children Mourning over the Ashes of Germanicus was painted for A. Vesey of Ireland in 1773 and shown that year at the Royal Academy; a mezzotint by Valentine Green was published in 1774. The picture is related in subject to a canvas West finished in 1768 for the King of *Agrippina Landing at Brundisium with the Ashes of Germanicus* (Yale University Art Gallery, New Haven). Germanicus, a popular Roman general, was believed to have been poisoned at the behest of his uncle, Emperor Tiberius, while on a campaign abroad. The story of this military hero who died in the service of his country and the stoic grief of his wife who accompanied him everywhere was seen as a noble example by the Enlightenment, as against the hedonism of the rococo. To the neo-classicists, these were not simply abstract virtues. In his famous picture *The Death of General Wolfe* (National Gallery of Canada, Ottawa) of three years before, West depicted a modern martyr who had died on the battlefield for his country. The French artist Jacques-Louis David would later take up the theme of self-sacrifice as a call to arms for the cause of republicanism, which overthrew the monarchy during the French Revolution.

The Ringling painting is a fine example of what has aptly been called West's Stately Mode. Executed in a style reminiscent of Guercino's, it uses a monumental scale to elevate the subject from a sentimental episode to a moral statement. Agrippina can be regarded as a secularized Penitent Magdalene and Mater Dolorosa. That the religious overtones are, in fact, deliberate is made clear by a preliminary drawing of 1771 (Historical Society of Pennsylvania, Philadelphia), which treats the subject as a variation on the Virgin and Child with the Infant St. John. Perhaps West decided the reference was too obvious. In its final form, the group of two playful children in the foreground was evidently derived from an engraving after an Etruscan mirror showing Dionysus embracing Semele.

Bibliography: J. Galt, *The Life, Studies, and Works of Benjamin West*, London, 1820, p. 223; G. Evans, *Benjamin West and the Taste of His Times*, Carbondale, 1954, pp. 48, 101, pl. 25.

Anton Raphael Mengs

German, 1728-1779

THE DREAM OF JOSEPH, 1773

oil on panel, 43 3/4 x 34. SN 328

The German-born Mengs spent most of his career in Rome. There he became the leading painter of the classical revival spearheaded by the archaeological discoveries of his fellow countryman Johann Winckelmann. Because little antique painting survived, however, Mengs relied on the examples of Raphael and Annibale Carracci. As he had to work his way back to their styles through later ones, he never entirely shed the vestiges of rococo form and color.

The Dream of Joseph is a late work which shows the end result of that process. It was probably done for the Earl of Cowper in 1773, when he had his portrait painted by Mengs. The picture is a replica of one executed in the same year for the Grand Duke of Tuscany as a pendant to a slightly earlier *Madonna and Child with Two Angels* (both are in the Kunsthistorisches Museum, Vienna). The idealization of the luminous angel, who is similar to earlier ones by Mengs, is a perfect foil for the vivid realism of the swarthy Joseph. The painting itself is dazzlingly beautiful in its lyrical color and immaculate execution, which show the influence of Raphael. Mengs evokes the renaissance master's monumental spirit again in a slightly later St. Peter (Kunsthistorisches Museum, Vienna), who is similar in type to Joseph.

The artist had first depicted *The Dream of Joseph* in a canvas of 1750 (Dresden Gemäldegalerie) that illustrates Matthew 1:20, in which the angel tells Joseph, "Fear not to take unto thee Mary thy wife; for that which is conceived in her is of the Holy Ghost." Based on early eighteenth-century Venetian paintings, it follows established tradition in showing the angel fluttering above Joseph. In the Ringling panel, however, Mengs brings us close up to the sleeping Joseph, who is seen in half-length with the angel standing behind him. The innovative composition, which seems to have been adopted only once previously in a canvas by Valentin de Boulogne (c. 1625, presently with Matthiesen Fine Art Ltd., London), suggests that this may be the second dream of Joseph, taken from Matthew 2:13, when the angel tells him to flee into Egypt.

Provenance: Third Earl of Cowper, London, 1773; Third Duke of Dorset; Duke of Westminster , Grosvenor House, by 1820; Christie, London, 1924; Arthur Newton; Sotheby, London, 1928.

Selected bibliography: J. Young, *Catalogue of the Pictures at the Grosvenor House, London*, London, 1820, p. 43, ill. p. 42; H. Voss, *Die Malerei des Barock in Rom*, Berlin, 1924, p. 659; D. Hönisch, *Anton Raphael Mengs*, Recklinghausen, 1965, no. 450?

Exhibition: *Homage to Mozart*, Wadsworth Atheneum, Hartford, 1956, no. 39, fig. 19.

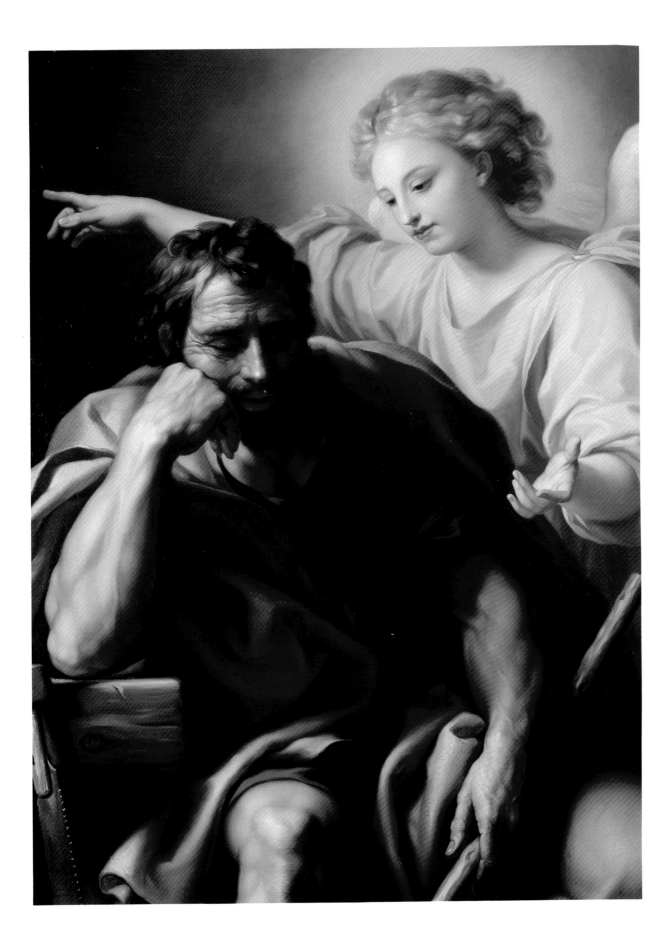

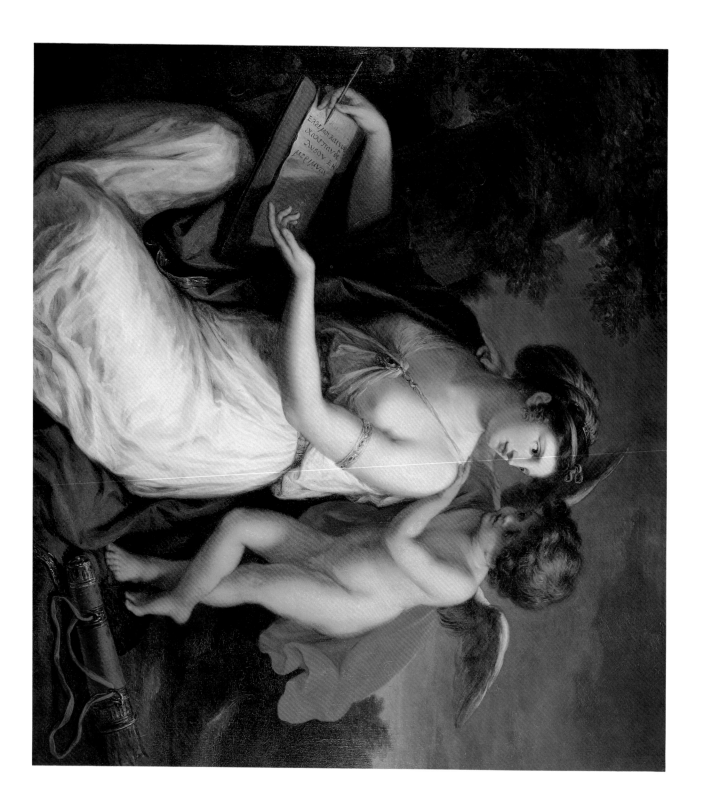

Angelica Kauffman
Swiss, 1741-1807
SAPPHO, 1775
oil on canvas, 51 x 58. SN 329

As a result of meeting the English neo-classical painters in Johann Winckelmann's circle in Rome, Angelica Kauffman spent fifteen years in London, where she was a close associate of Benjamin West, Henry Fuseli and the other members of the Royal Academy. She devoted herself to decorative paintings of muses and like figures, which are generally more notable for their charm than their content. *Sappho*, one of her most beautiful works, has both. Inspired by Eros, the legendary Greek poet is seen writing the verse "So come again and deliver me/from intolerable pain" from her *Ode to Aphrodite*. As Fuseli observed, "Her heroines are herself," and it has been persuasively suggested that the painting held particular meaning for Kauffman. On the one hand, she had a reputation, seemingly justified, for amorous affairs. On the other hand, Sappho was the symbol of women's achievement in the arts, which Kauffman struggled to gain. That the artist has invested the face of Sappho with some of her own features attests to her sense of identification with the poet. The composition no doubt was taken from Guercino's *The Cumaean Sibyl* (Denis Mahon Collection, London), perhaps through the intermediary of a print as it is shown in reverse.

Signed and dated l.r.: Angelica Kauffman pinx. 1775

Provenance: John Baker Holyroyd, First Earl of Sheffield; sold Sotheby, London, February 22, 1928; Julius Böhler Gallery, Munich; John Ringling.

Bibliography: P. A. Tomory, "Angelica Kauffman — 'Sappho'," *The Burlington Magazine*, CXIII, 818, May, 1971, pp. 275-276.

Exhibition: Royal Academy, London, 1775, no. 169.

Claude-Joseph Vernet
French, 1714-1789
*PAYSAGE MARINE — BLANCHISSEUSES
(LANDSCAPE WITH WASHERWOMEN)*
late 1740s
oil on canvas, 31 1/2 x 45. SN 944

From the early seventeenth through the mid-nineteenth centuries, the landscape tradition in Italy was shaped as much by northern artists as by Italian painters. Thus, it was the foreigner Vernet who became its leading representative from 1740 until he was called back to France in 1752. *Landscape with Washerwomen* uses a compositional type he favored during the late 1740s in works such as *Landscape with Waterfall* (1747, Duke of Buccleuch and Queensbury). Within a design scheme by the early eighteenth-century Dutch Italianate painter Jacob de Heusch, it incorporates elements drawn from Vernet's great French predecessor Claude Lorrain, as well as from Poussin's nephew Gaspard Dughet and the Neapolitan Salvator Rosa. Vernet's achievement lies not so much in his synthesis as in the new note of naturalism that unifies the painting. Although the scene is obviously imaginary, it is rendered with such attention to detail and fidelity to light that it is utterly convincing. Vernet was among the first to pose truth to nature — which was to become a rallying cry for the romantics — as an alternative to the landscape fantasies of the rococo. Because of his numerous British patrons, he exercised an important influence on the development of the English picturesque school.

Provenance: painted for the artist's friend Balthazar; Thomas Bryan; New York Historical Society, 1867; Parke-Bernet, New York, 1971; David David Gallery, Philadelphia, acquired 1975.

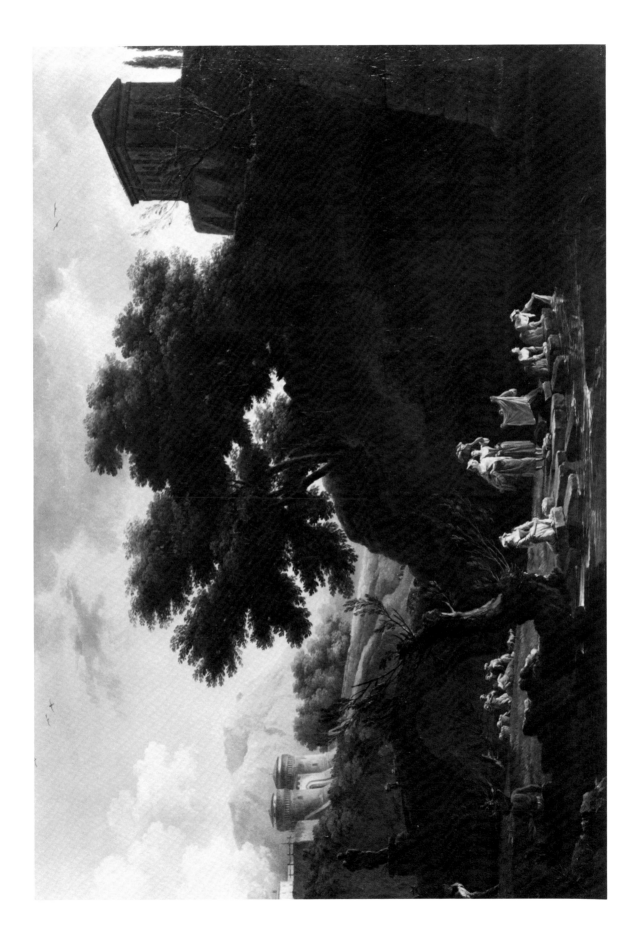

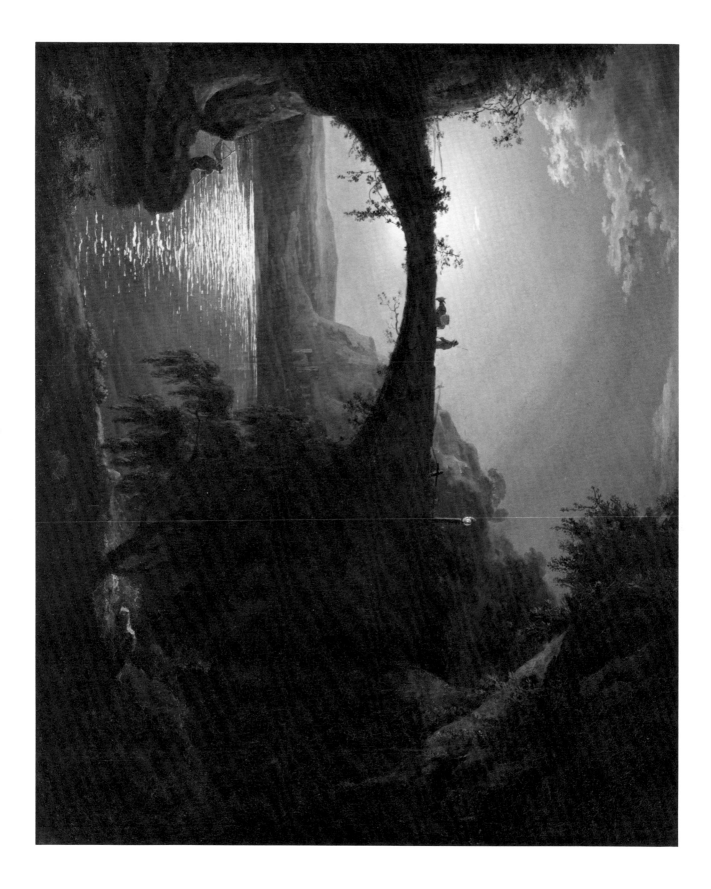

Joseph Wright of Derby
English, 1734-1797
MOONLIGHT LANDSCAPE, c. 1785
oil on canvas, 25 1/2 x 30 1/2. SN 906

Wright's fame rests with his early pictures of scientific experiments. These were stimulated by his membership in the Lunar Society of Birmingham, which included James Watt, Erasmus Darwin, and Josiah Wedgwood, who were his major patrons as well. He was also a leading painter of mythological subjects, taken from classical and English literature, and a skilled portraitist in the general manner of Reynolds. The last twenty years of his life were devoted principally to landscape, however. Wright's interest may have been sparked initially by Thomas Smith of Derby, but it was his trip to Italy in 1774-1775 that proved decisive. Upon his return, Italy and his native Derbyshire provided his settings. Indeed, it is sometimes difficult to tell them apart, because both kinds of pictures follow the same prescriptions. Often his scenes are fantasies, and he was not above combining features from vastly different locales. The Ringling painting is distinguished from his views around Derby, which it otherwise closely resembles, only by its smoother topography.

Like many of Wright's landscapes, this is a haunting nocturne. Because of his passion for eerie light effects, he is often considered a precursor of romanticism. Wright, however, belongs to the Enlightenment, with which he was in complete sympathy philosophically. In fact, his landscapes fall entirely within the eighteenth-century landscape tradition. His Italian pictures were influenced by Claude-Joseph Vernet, and they often share Hubert Robert's fascination with firework displays, catastrophic fires, and the eruption of Mount Vesuvius, which he witnessed in 1774 and depicted many times. The Derby landscapes, especially those of Matlock, adhere to the English picturesque school.

As the term indicates, the picturesque was based on artistic examples. The pastoral landscapes of Claude Lorrain and the wild scenery of Salvator Rosa first opened the eyes of the English to nature as an aesthetic experience, which was validated by poets such as James Thompson. The picturesque also included topographical and rustic modes, as well as a purely imaginary element fostered by Alexander Cozens. The enthusiasm for the remote areas of Britain like Derbyshire was kindled by William Gilpin's *A Guide to the Lakes in Cumberland, Westmorland, and Lancashire* (1780). Gilpin separated the picturesque from the sublime and the beautiful on the grounds that it was neither vast nor smooth, but rough and finite.

Moonlight Landscape suggests the impact of Gilpin's theories in its synthesis of the beautiful and the picturesque. To achieve this harmony, Wright relied chiefly on the example of Gaspard Dughet, Poussin's nephew, who successfully incorporated aspects of both Claude and Rosa into his style. Wright's paintings remain landscapes of mood. The picturesque is separated from romanticism proper by the emotional pantheism that underlies nineteenth-century landscape painting. Absent from his work is the sense of divine presence seen in Turner's phantasmagorias, or the personal identification with nature that marks Constable's views of the Stour.

Provenance: David David Gallery, Philadelphia, acquired 1972.

Rosa Bonheur
French, 1822-1899
LE LABOURAGE NIVERNAIS: LE SOMBRAGE
(PLOUGHING IN NIVERNAIS), 1850
oil on canvas, 52 1/2 x 102. SN 433

Rosa Bonheur was the most famous woman artist of her time and ranked as one of the leading animal painters during the second half of the nineteenth century. Her first major success at the Salon of 1848 was tied to the Revolution of 1848, which elevated Jean-François Millet and the romantics on the one hand and Gustave Courbet and the realists on the other to prominent positions in French art. *Le labourage nivernais* is a replica with minor variations of the canvas she sent to the Salon in 1849 (Musée National du Château de Fontainebleau) after spending the winter working from nature in the Nièvre region. The picture won even greater praise than her entry of the previous year, and became one of the most copied works of the nineteenth century. It takes up the theme, made popular by the author George Sand among others, of the harmonious union of man and nature, and was intended "as a kind of celebration of the furrows from which mankind receives the bread which nourishes it." *Le labourage nivernais* treats peasant life with a monumentality that evokes the reverence of Millet while sharing the naturalism of Courbet. However, it lacks the heroic overtones of the former and the Socialist implications of the latter. As in all of Bonheur's work, the real subject is the animals in the landscape, which is depicted with such accuracy that one can almost smell the fertile soil in the spring afternoon.

Signed and dated l.r.: Rosa Bonheur 1850

Provenance: Viscount Hambledon; Christie, London, March 1, 1929, no. 177; Mitchell Gallery, London.

Selected bibliography: A. Klumpke, *Rosa Bonheur, Sa Vie, Son Oeuvre*, Paris, 1908, p. 196; Suida, no. 433; R. Shriver, *Rosa Bonheur*, East Brunswick, 1982, pp. 29, 53.

Exhibitions: *Artists of the Paris Salon*, Cummer Gallery of Art, Jacksonville, 1964, no. 2; *French Salon Paintings from Southern Collections*, High Museum of Art, Atlanta, 1983, no. 4.

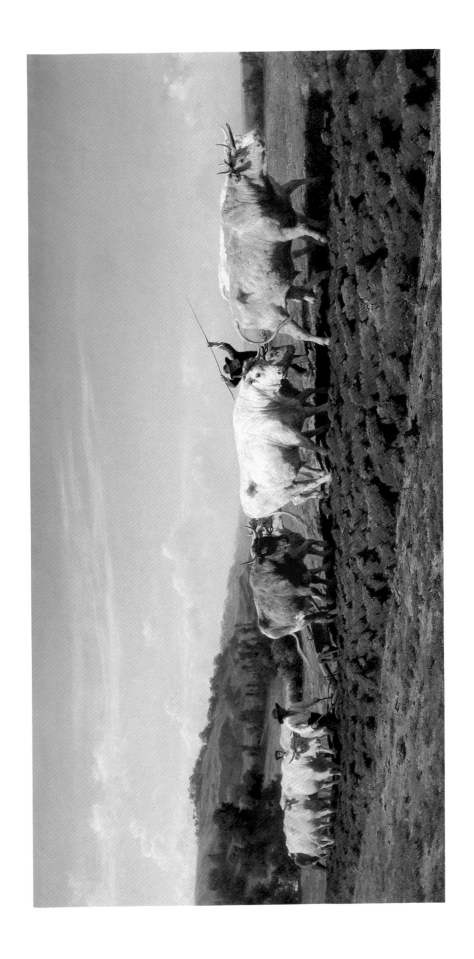

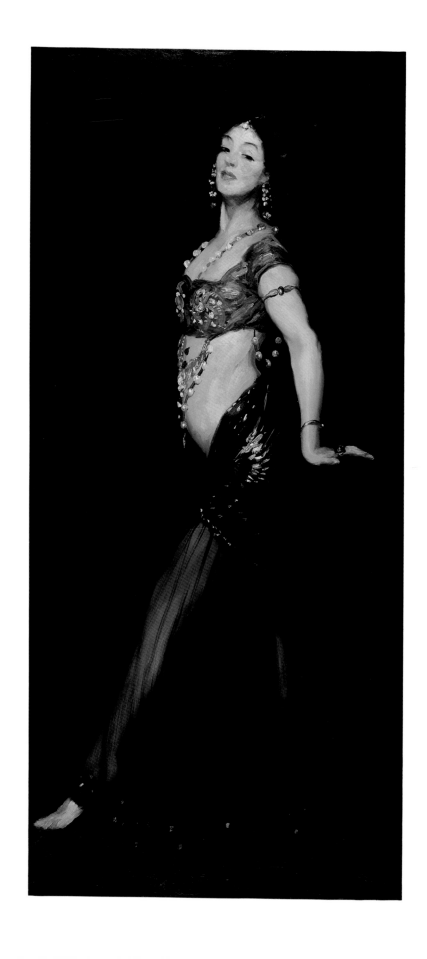

Robert Henri
American, 1865-1929
SALOME, 1909
oil on canvas, 77 x 37. SN 937

Henri was the leader of the Ash Can School, the group of former Philadelphia newspaper illustrators who were the first American artists to focus on the urban scene. Their point of departure was the post-impressionist style Henri evolved during a critical stay in Paris in 1895-1897. Despite the socialism they espoused, Henri and his followers were not artistic radicals, and they became the bitter rivals of the modernists, headed by Alfred Stieglitz. Ironically, Henri played an important role in staging the Armory Show of 1913, which opened the door to European abstraction in the United States.

Henri's best work was done before the Armory Show. Thereafter, he became increasingly obsessed by the color theories of Hardesty Maratta, which gradually undermined his art. From 1903 on, he turned mainly to figure paintings and portraits, which made him the successor to William Merritt Chase. Like Chase, he adopted the dark backgrounds and painterly brushwork of baroque art. His masteriece, *The Masquerade Dress: Portrait of Mrs. Henri* (1911, Metropolitan Museum), is a brilliant summation of the tradition of Edouard Manet and James McNeill Whistler through John Singer Sargent and Chase.

Though very different in character, *Salome* ranks as an equal achievement. This is the second of two canvases Henri painted in 1909 depicting the soprano Mademoiselle Voclezca in the title role in Richard Strauss's opera. The other version (Mead Art Gallery, Amherst College) shows her in the same exotic costume with two veils, but as in most of his paintings the pose is static. It was the artist's practice to focus his attention on formal arrangement and facial expression. Those concerns are no less in evidence here, but in no other picture did he attempt such daring movement or capture its energy with such success. He has chosen precisely the most characteristic view of the seductive dance and conveyed its essence with a loaded brush that traces its sinuous motion.

Provenance: Estate of Robert Henri; Chapellier Galleries, New York, acquired 1974.

Selected exhibition: *Robert Henri, Painter*, Delaware Art Museum, 1984, no. 61.

Reginald Marsh
American, 1898-1954
WONDERLAND CIRCUS, SIDESHOW, CONEY ISLAND, 1930
tempera on masonite, 47 1/2 x 47 1/2. SN 951

Marsh was heir to the Ash Can School through his principal teacher, Kenneth Hayes Miller, who had been a pupil of Robert Henri. He emerged as a mature artist only in 1930 after a decade of study while working for *The New York Daily News* and then *The New Yorker.* Like the artists of the Ash Can School, he found the teeming city an endless source of picturesque subjects, from the squalor of the Bowery to the strip joints of Times Square. He was at his best, however, in depicting Coney Island, where masses of working-class New Yorkers congregated to seek enjoyment and escape the summer heat, and it was to become his most characteristic theme.

Sideshow is one of Marsh's first major paintings. As is often the case with his scenes, the composition looks very much like a stage set, reflecting his involvement with the theater in the 1920s. The picture is a compilation of observations that the artist habitually recorded in his sketchbooks. There is an obvious element of caricature in what were to become familiar types in his work. Marsh was an avowed anti-modernist with a keen interest in the renaissance and baroque, which he developed during numerous trips to Europe. Although the Old Masters did not provide him with subject matter, their influence can often be seen in individual figures. Here, the woman in yellow tights seen from behind directly recalls Hendrick Goltzius's engraving of *The Farnese Hercules.*

Marsh's traditionalism is further reflected in his technique. The painting is treated almost like a giant watercolor using thin layers of tempera. He soon came to prefer this medium to the thick oils of the Ash Can School, because it allowed him to draw with the brush. The surface thus retains a distinctly graphic quality and, indeed, he translated the picture into an etching a year later. He had been introduced to tempera in 1929 by Thomas Hart Benton, the leader of the regionalists, who was among the first to appreciate the cheerful vitality of his work. The colors have the vividness of Marsh's early pictures. Within a few years, at the depth of the Depression, he adopted an appropriately more subdued palette of earth colors under the influence of the social realists, whose subject matter and political views he shared but whose social commentary he shunned.

Signed and dated l.r.: Reginald Marsh/1930

Provenance: Frank Rehn Gallery, New York; Huntington Hartford Collection; Private Collection, New York; Shapiro Gallery, St. Louis; Andrew Crispo Gallery, New York, acquired 1976.

Bibliography: L. Goodrich, *Reginald Marsh,* New York, 1972, pp. 42-43, ill. p. 104.

Exhibitions: *Reginald Marsh Memorial Exhibition,* Whitney Museum of American Art, New York, 1955; *Four Centuries of American Art,* Minneapolis Institute of Arts, 1963.

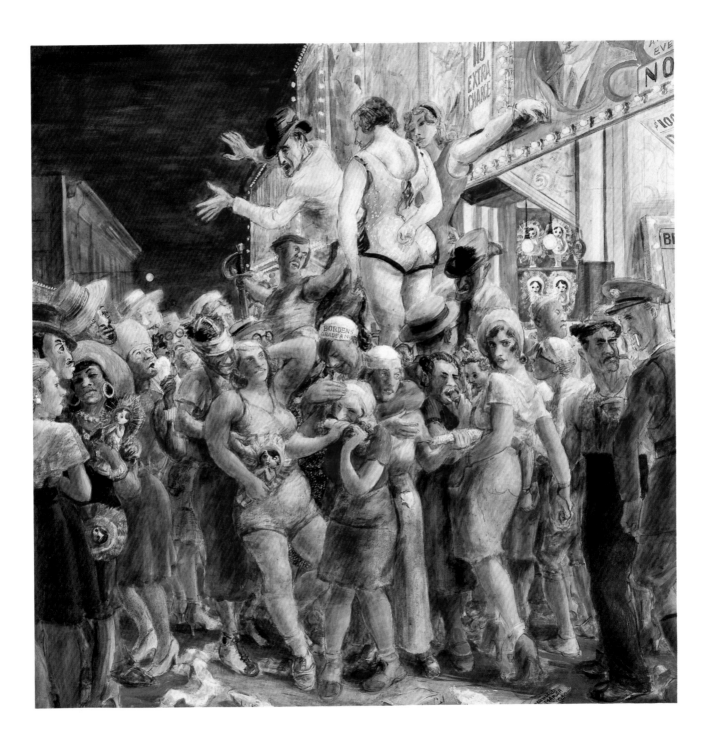

OTHER NOTABLE PAINTINGS

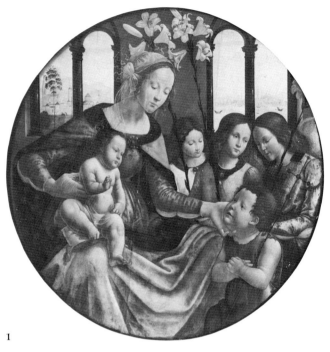

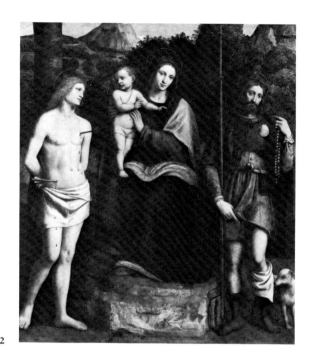

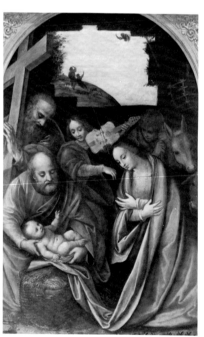

1

3

4

ITALIAN

1. Sebastiano Mainardi, Italian, active 1493-1513, *MADONNA AND CHILD WITH ST. JOHN,* 1490s, oil on panel 56 1/4 x 37, SN 20

2. Bernardo Luini, Italian c. 1481-1532, *THE MADONNA AND CHILD WITH ST. SEBASTIAN AND ST. ROCHE* c. 1522, oil on panel, 69 x 61 1/2, SN 37

3. Bernardo Lanino, Italian, active c. 1530 - early 1580s, *THE NATIVITY WITH ST. PHILIP,* 1565-1567 oil on panel, 56 1/4 x 37, SN 42

4. Domenico Puligo, Italian 1492-c. 1527, *THE VIRGIN AND CHILD WITH ST. BENIGNUS AND ST. PLACIDUS* 1526, oil on panel, 61 x 67 1/4, SN 28

5. Maso da San Friano, Italian, c. 1531-1571, *MADONNA AND CHILD WITH THE MAGDALEN*, c. 1560s oil on panel, 34 3/4 x 27 1/2, SN 685

6. Andrea del Brescianino, Italian, active 1507-after 1525, *PORTRAIT OF A YOUNG WOMAN HOLDING A BOOK*, oil on panel, 30 1/2 x 24 1/2, SN 25

7. Francesco Salviati, Italian, 1510-1563, *PORTRAIT OF A YOUTH OF THE MEDICI FAMILY*, c. 1554 oil on panel, 27 1/2 x 19, SN 733, Gift of E. Milo Greene

8. Giovanni Battista Moroni, Italian, active 1546-1578, *PORTRAIT OF MARIO BENVENUTI*, 1550s oil on canvas, 45 5/8 x 36, SN 106

9

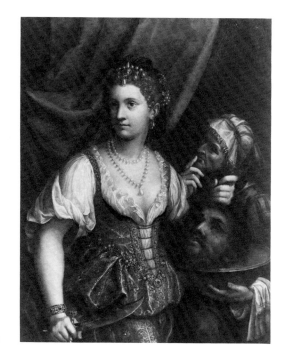

10

11

12

9. Paolo Veronese, Italian, c. 1528-1588, *PORTRAIT OF FRANCESCO FRANCHESCHINI,* 1551, oil on canvas 74 x 53, SN 81

10. Fede Galizia, Italian, c. 1578-1630, *JUDITH WITH THE HEAD OF HOLOFERNES,* 1596, oil on canvas 47 1/2 x 37, SN 684, Gift of Jacob Polak

11. Jacopo Bassano, Italian, 1510-1592, and **Francesco Bassano,** Italian, 1549-1592, *ALLEGORY OF FIRE,* c. 1590 oil on canvas, 55 x 77 5/8, SN 86

12. Jacopo Bassano, Italian, 1510-1592, and **Francesco Bassano,** Italian, 1549-1592, *ALLEGORY OF WATER* c. 1590, oil on canvas, 55 x 77 5/8, SN 87

13. Il Padovanino (Alessandro Varotari), Italian, 1588-1648, *DEIANIRA AND THE CENTAUR NESSUS*
oil on canvas, 72 1/8 x 56 5/8, SN 142

14. Cavaliere d'Arpino (Giuseppe Cesare), Italian, 1568-1640, *PERSEUS AND ANDROMEDA*, c. 1602
oil on canvas, 28 5/8 x 20 5/8, SN 108

15. Francesco Albani, Italian, 1578-1660, *ST. JOHN THE BAPTIST IN THE WILDERNESS*, c. 1602, oil on copper
19 3/8 x 14 5/8, SN 115

16. Massimo Stanzione, Italian, c. 1585-1656, *ST. CECILIA*, late 1630s, oil on canvas, 59 1/4 x 40 3/8, SN 134

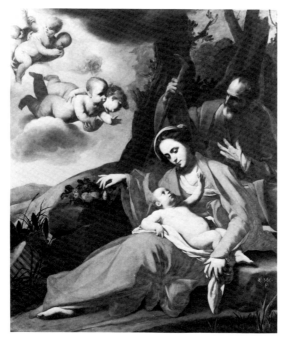

17

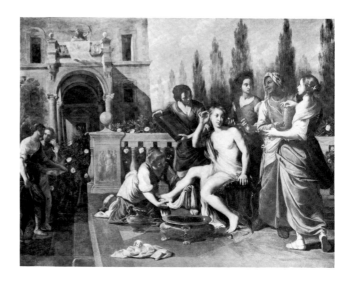

18

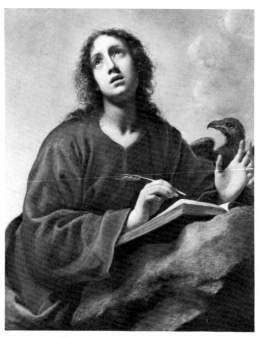

19

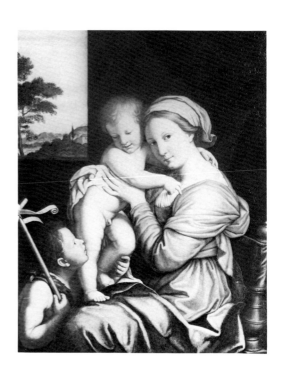

20

17. Massimo Stanzione, Italian, c. 1585-1656, *THE REST ON THE FLIGHT INTO EGYPT,* c. 1646, oil on canvas 71 1/2 x 61 1/2, SN 146

18. Domenico Gargiulo (Micco Spadaro), Italian, c. 1612-c. 1679, *THE TOILET OF BATHSHEBA,* oil on canvas 33 1/4 x 45 1/2, SN 955, Gift of Asbjorn R. Lunde

19. Carlo Dolci, Italian, 1616-1686, *ST. JOHN WRITING THE BOOK OF REVELATION,* c. 1647, oil on copper 10 1/4 x 8 1/8, SN 137

20. Sassoferrato (Giovanni Battista Salvi), Italian, 1609-1685, *MADONNA AND CHILD,* c. 1645-1655 oil on canvas, 35 1/2 x 28 1/2, SN 127

21

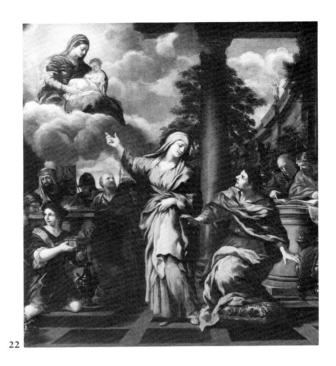

22

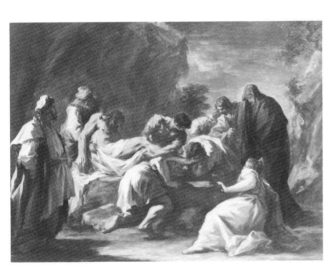

23

24

21. Sassoferrato (Giovanni Battista Salvi), Italian, 1609-1685, *CARDINAL PAOLO EMILIO RONDININI* c. 1642-1652, oil on canvas, 87 x 64, SN 128

22. Pietro da Cortona, Italian, 1596-1669, *AUGUSTUS AND THE SIBYL,* c. 1660, oil on canvas, 56 1/2 x 53 3/4, SN 133

23. Giovanni Antonio Pellegrini, Italian, 1675-1741, *THE ENTOMBMENT,* 1719, oil on canvas, 38 1/2 x 50 1/2 SN 176

24. Sebastiano Conca, Italian, 1680-1764, *THE VISION OF AENEAS IN THE ELYSIAN FIELDS,* c. 1735-1740 oil on canvas, 48 1/2 x 68 1/4, SN 168

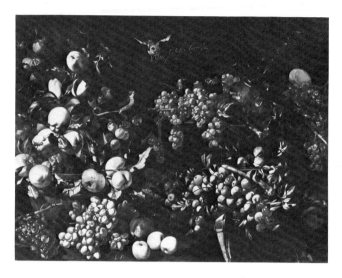

25

26

27

28

25. Luca Forte, Italian, active 1625-1655, *STILL LIFE WITH FRUIT,* late 1640s, oil on canvas, 31 x 41 1/4, SN 715

26. Cristoforo Munari, Italian, 1667-1720, *STILL LIFE WITH PLATES,* c. 1706-1709, oil on canvas, 35 1/4 x 47 1/2, SN 660

27. Francesco Fieravino (Il Maltese), Italian, active 1640s, *STILL LIFE WITH DOG,* oil on canvas, 34 3/4 x 48 1/2, SN 806, Gift of U. Morgan Davies

28. Salvator Rosa, Italian, 1615-1673, *LANDSCAPE WITH A LAKE,* c. 1655, oil on canvas, 48 x 80 1/2, SN 154

29

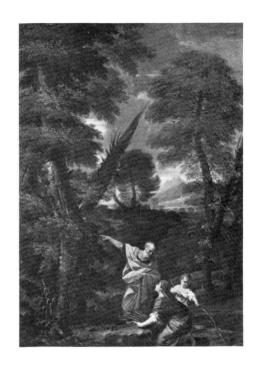
30

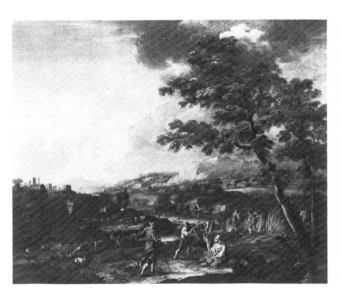
31

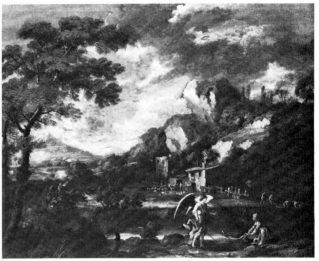
32

29. Pier Francesco Mola, Italian, 1612-1666, *THE PROPHET ELIJAH AND THE WIDOW OF ZARAPHATH*
c. 1650, oil on canvas, 25 3/4 x 19, SN 138

30. Pier Francesco Mola, Italian, 1612-1666, *THE PROPHET ELIJAH AND THE RICH WOMAN OF SHUNEM*
c. 1650, oil on canvas, 25 3/4 x 19, SN 139

31. Marco Ricci, Italian, 1676-1730, *LANDSCAPE WITH RUTH AND BOAZ,* c. 1715, oil on canvas, 30 x 37 1/4
SN 180

32. Marco Ricci, Italian, 1676-1730, *LANDSCAPE WITH TOBIAS AND THE ANGEL,* c. 1715, oil on canvas
30 x 37 1/4, SN 179

33

34

35

33. Pier Francesco Mola, Italian, 1612-1666, *PORTRAIT OF A YOUNG MAN,* 1650s, oil on canvas, 29 1/2 x 24
SN 905

34. Luca Carlevaris, Italian, 1665-1731, and **Giovanni Richter?,** *PIAZZA SAN MARCO TOWARDS SAN MARCO*
c. 1725, oil on canvas, 25 x 39 1/8, SN 669

35. Luca Carlevaris, Italian, 1665-1731, and **Giovanni Richter?,** *PIAZZA SAN MARCO TOWARDS THE
PIAZETTA,* c. 1725, oil on canvas, 25 x 39 1/8, SN 670

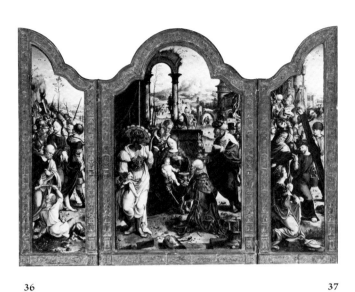

36

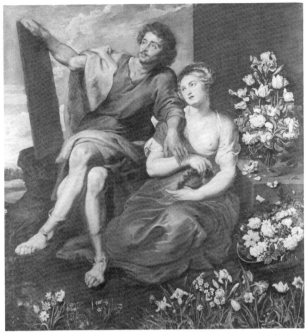

37

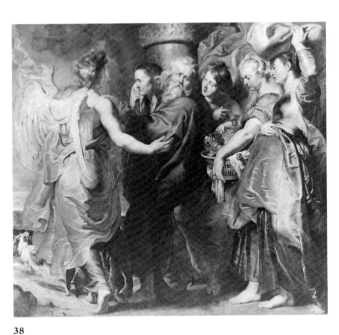

38

39

FLEMISH

36. Master of the Bob Jones Altarpiece, Flemish, *TRIPTYCH,* c. 1530s, oil on panel, 36 x 41 1/4 (overall)
SN 203

37. Peter Paul Rubens, Flemish, 1577-1640, and **Osias Beert the Elder,** Flemish, c. 1580-1624, *PAUSIAS AND GLYCERA,* ca. 1615, oil on canvas, 80 x 76 1/2, SN 219

38. Peter Paul Rubens, Flemish, 1577-1640, *THE DEPARTURE OF LOT AND HIS FAMILY, FROM SODOM* c. 1615, oil on canvas, 86 3/4 x 96, SN 218

39. Jacob van Es, Flemish, c. 1596-1666, *STILL LIFE WITH OYSTERS,* c. 1635-1640, oil on panel, 21 1/4 x 29 SN 661

40

41

40. David Teniers, Flemish, 1610-1690, *FIDDLER IN A TAVERN,* 1640s, oil on panel, 14 x 18 3/4, SN 243

41. Adriaen van Utrecht, Flemish, 1599-1653, *STILL LIFE WITH CATS AND MONKEYS,* c. 1635 oil on canvas 29 1/2 x 42 1/2, SN 235

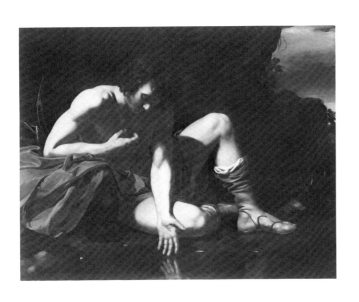

42

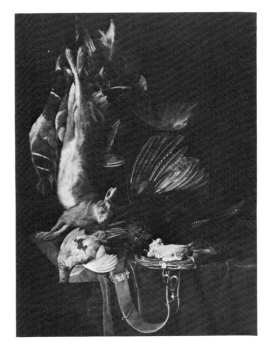

43

44

45

DUTCH

42. Gerard van Kuijl, Dutch, 1603-1673, *NARCISSUS,* late 1640s, oil on canvas, 56 x 75, SN 885

43. Willem van Aelst, Dutch, 1626-1683, *STILL LIFE WITH DEAD GAME,* late 1660s, oil on canvas, 53 7/8 x 41 7/8, SN 655

44. Jan Lingelbach, Dutch, 1622-1674, *A HARBOR SCENE IN ITALY,* 1667, oil on canvas, 33 1/2 x 45, SN 272

45. Nicolaes Maes, Dutch, 1634-1693, *ENGELBERTA VAN BRIENEN,* c. 1674, oil on canvas, 40 x 30, SN 266

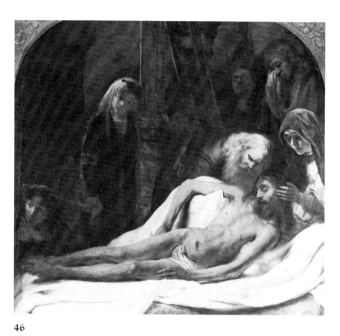

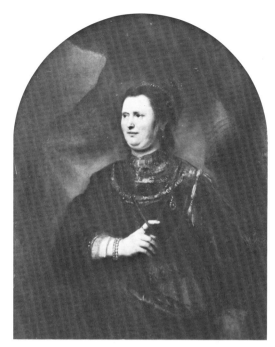

46

47

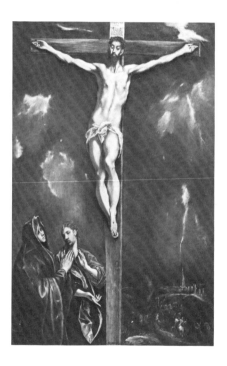

48

46. Reynier van Gherwen, Dutch, d. c. 1662, *LAMENTATION*, late 1640s, oil on canvas, 71 x 78 1/4, SN 252

47. Reynier van Gherwen, Dutch, d. c. 1662, *PORTRAIT OF A WOMAN*, early 1650s, oil on panel, 54 x 40 SN 253

SPANISH

48. El Greco (Domenico Theotokopoulos), Spanish, 1541-1614, and **Jorge Manuel Theotokopoulos,** Spanish 1578-1631, *CHRIST ON THE CROSS*, c. 1603-1605, oil on canvas, 41 3/4 x 27 1/4, SN 333

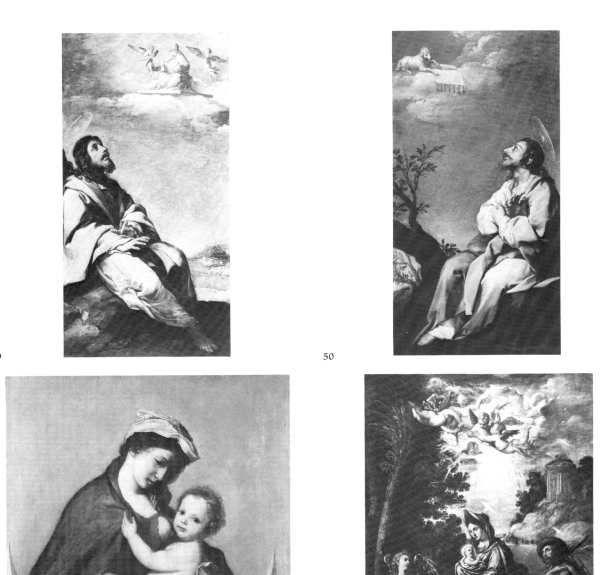

49 50

51 52

49. Alonso Cano, Spanish, 1601-1667, *ST. JOHN THE EVANGELIST'S VISION OF GOD,* 1638, oil on canvas
28 x 15 1/2 each, SN 344

50. Alonso Cano, Spanish, 1601-1667, *ST. JOHN THE EVANGELIST'S VISION OF THE LAMB,* 1638
oil on canvas, 28 x 15 1/2 each, SN 345

51. Jusepe de Ribera, Spanish, 1588-1652, *MADONNA AND CHILD,* 1643, oil on canvas, 43 3/4 x 39 1/2
SN 334

52. Juan de Pareja, Spanish, 1610-c. 1670, *THE FLIGHT INTO EGYPT,* 1658, oil on canvas, 66 1/2 x 49 3/8
SN 339

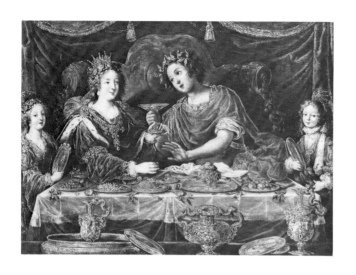

53

54

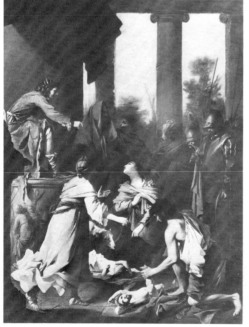

55

56

FRENCH

53. Claude Vignon, French, 1593-1670, *THE BANQUET OF ANTHONY AND CLEOPATRA,* c. 1640 oil on canvas, 34 1/4 x 44 1/4, SN 653

54. Nicolas Poussin, French, 1594-1665, *THE ECSTASY OF ST. PAUL,* 1643, oil on panel, 16 1/4 x 11 7/8 SN 690

55. Jean Tassel, French, c. 1608-1667, *THE JUDGMENT OF SOLOMON,* c. 1650s, oil on canvas, 31 3/4 x 25 1/2 SN 702

56. Nöel-Nicolas Coypel, French, 1690-1734, *MADAME DE BOURBON-CONTI,* 1731, oil on canvas, 54 1/8 x 41 7/8, SN 381

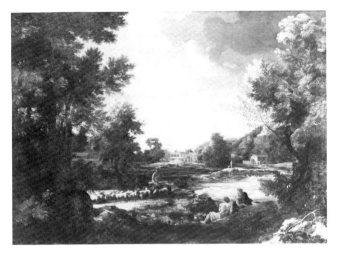

57

58

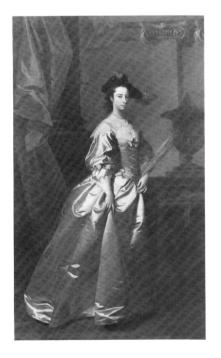

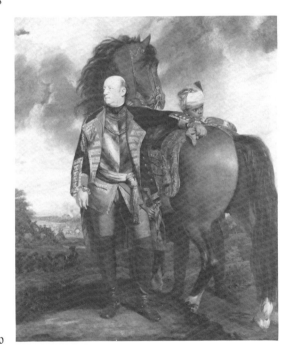

59

60

57. Gaspar Dughet, French-Italian, 1615-1675, *A VALLEY AFTER A SHOWER,* 1650s, oil on canvas, 38 3/8 x 53 1/4, SN 362

58. Eugène-Louis Boudin, French, 1824-1898, *VIEW OF DUNKIRK,* 1880, oil on canvas, 16 1/8 x 21 7/8, SN 436

ENGLISH

59. Allan Ramsay, English, 1713-1784, *PORTRAIT OF MARY LILLIAN SCOTT,* oil on canvas, 92 x 56 1/2 SN 387

60. Joshua Reynolds, English, 1723-1792, *PORTRAIT OF THE MARQUIS OF GRANBY,* 1766, oil on canvas 96 5/8 x 82, SN 389

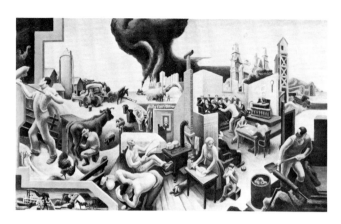

61

62

63

AMERICAN

61. Thomas Hart Benton, American, 1889-1975, *INTERIOR OF A FARM HOUSE (STUDY FOR MURAL, MISSOURI STATE CAPITOL BUILDING),* 1936, tempera on board, 18 x 30, SN 950

62. Arthur Dove, American, 1880-1946, *MARS YELLOW, RED AND GREEN,* 1943, oil on canvas, 18 x 28 SN 935

63. Philip Pearlstein, American, b. 1924, *FEMALE MODEL ON LADDER,* 1976, oil on canvas, 72 x 96, SN 979